ST. PETERSBURG'S
HISTORIC 22ND STREET SOUTH

ST. PETERSBURG'S

HISTORIC 22ND STREET SOUTH

To Gaye —
With best wishes
Rosalie Peck

Gaye,
Hope you enjoy reading it
as much as we enjoyed
writing it!
Best,
Jon Wilson

ROSALIE PECK AND JON WILSON

Charleston London

History
PRESS

Published by The History Press
18 Percy Street
Charleston, SC 29403
866.223.5778
www.historypress.net

Front Cover: Geech's barbecue was a community institution for years, featuring a yellow sauce, whose recipe owner John "Geech" Black is said to have taken to his grave. The customers in this photo, taken during the late 1950s, are not identified. *Courtesy Norman Jones II.*
Back Cover: Dr. Ralph Wimbish integrated the downtown Maas Brothers lunch counter in 1961. *Courtesy* St. Petersburg Times.

First published 2006
Manufactured in the United Kingdom
ISBN 1.59629.083.8

Peck, Rosalie.
 St. Petersburg's historic 22nd Street South / Rosalie Peck and Jon
Wilson.
 p. cm.
 Includes bibliographical references.
 ISBN 1-59629-083-8 (alk. paper)
 1. Twenty-second Street (Saint Petersburg, Fla.)--History.
2. African Americans--Florida--Saint Petersburg--History.
3. African American neighborhoods--Florida--Saint Petersburg
--History. 4. African Americans--Florida--Saint Petersburg--Bio-
graphy. 5. Saint Petersburg (Fla.)--History. 6. Saint Petersburg
(Fla.)--Biography. 7. Oral history. 8. Saint Petersburg (Fla.)
--Race relations. I. Wilson, Jon, 1945- . II. Title.
F319.S24P43 2006
975.9'6300496073--dc22
 2005033534

Contents

Acknowledgements

M any people helped with this book and all should get thanks and hugs, though getting one's arms around all requires a reach longer than we can manage. Encouragement emerged throughout the community.

The *St. Petersburg Times* recognized early on the importance of preserving a piece of the city's African American cultural heritage. As an organization, the newspaper enthusiastically supported the 2002 publication of "The Deuces," a special report about 22nd Street South's history, its future and its meaning to the city. That project jump-started this book.

In particular, Neil Brown encouraged the newspaper presentation and suggested ways to make it better. Jim Verhulst got excited about the idea and remained so, despite its rather deliberate production pace. A fine wordsmith, Verhulst applied his talent to the editing job and some of his phrasing doubtless survives in this work. Kevin McGeever offered pertinent suggestions and good-humored encouragement when enthusiasm waned. Artist Don Morris embraced the newspaper phase and was particularly helpful during the book phase. When that part of the project began to take shape, senior editor Jim Booth opened every door he could. *Times* files and resources proved invaluable. Photographer Jamie Francis, some of whose work appears in these pages, provided inspiration and depth, and other *Times* newsphoto folks such as Jack Rowland, Kathy Hughes and Lynn Seelye deserve special thanks. Researchers Mary Mellstrom and Cathy Wos pitched in. Graphics librarians Claire Giglio, Sharon Dufford, Carolyn Alderson and Cary Kenney

fished through ancient archives in search of old photos. Debbie Wolfe helped retrieval from computer files.

We would like to thank Goliath Davis, the city of St. Petersburg's deputy mayor for Midtown, for keeping us up to speed on the latest 22nd Street developments and for offering historical perspective.

Cynda Mort, who teaches at Melrose Elementary School, helped us make an important connection.

Most of all, we want to express gratitude to the people who have seen St. Petersburg pass through its eras and who have held tight to it in hard times and good. The stories, photographs and enthusiasm they passed along brought life to the 22nd Street story and faith in the idea of community, regardless of its contradictions and counterpoint. We especially would like to mention Joseph and Ada Albury, Abdul Karim Ali, Alfred Ayer, Ellen Babb, Joseph N. Brown, Samuel Blossom, Sevelle Brown, Eloise Christian, Buster and Sarah Cooper, Mabel Cooper, William and Carolyn Dandy, Annie Jewel Dandy, Jay Dobkin, Evander and Beverly Duck, Raymond L. Deloach, Betty Fuller, William and Annette Howard, Ray Hinst, Larry Jones, Mary L. Brayboy Jones, Norman Jones II, Bunnie Katz, James H. Keys, Virginia Littrell, the Rev. and Mrs. Alvin Miller, Tangela Murph, Grant McCray, Charlie Parker, Nadine Price, Ann Perkins, Margaret Robinson, Sandra Rooks, Gwendolyn Reese, Inez Rodriquez, Sandra Rooks, Jacob "Jake" Simmons, Douglas and Nadine Seay, John L. Smith Jr., Ann Taylor, Ramon Thomas, Esther Peck Thomas, Eunice Woodard, Henry Woodard, Clara Woodard, Clarence E. "Shad" Williams, Kent Whittemore, Ophelia Wilson, Gussie Strong Wilkerson, Mordecai Walker, Genorice Davis White and Omali Yeshitela.

Finally, a large measure of gratitude goes to Becky Wilson, wife of one co-author, friend to the other, who hugged when needed, listened as required and, most importantly, took care of our ever-present issues with the technology of home computers.

Introduction

On a November night in 1921, two explosions rattled the Dream Theater, a new movie house on 9th Street South for St. Petersburg's black residents. Someone had bombed it. No one was hurt, but the message was as loud as the blasts. The *St. Petersburg Times* report said: "The theater was blown up because white residents of the section…objected to the Negroes congregating in the place."

The theater closed, and, as so often happened in the decades that followed, black residents were pushed out of the way. On what was then the edge of a growing city officially not quite three decades old, African Americans began to create a community of their own along a dirt trail called 22nd Street South. Surrounded by pine trees and palmetto bushes, it was in the country, part of a sprawling tract the city government had recently annexed.

As it slowly but steadily developed, the neighborhood became a town within a town, in many ways self-sustaining. Places to buy groceries and clothing sprouted. African Americans opened medical and law practices, funeral homes and beauty shops. Entertainment spots blossomed.

Eventually, 22nd Street became one of the nation's African American main streets—a smaller version of such promenades as Atlanta's Sweet Auburn, Beale Street in Memphis or Ashley Street in Jacksonville. Old-timers suggest perhaps 75 percent of more than one hundred businesses on 22nd were black-owned during the late 1950s and early 1960s.

All were supported by a black citizenry that, from census to census, consistently composed 15 to 20 percent of St. Petersburg's ever-growing population. Black

residents were helping build St. Petersburg, but Jim Crow custom shunted them to the city's geographical and social margins.

The exclusion fostered need, and it made 22nd Street thrive during its half-century heyday. "That's the only way we could exist with any spirit, because we were not looked on as human," said the late Peggy Peterman, a keen observer who was a *St. Petersburg Times* staff writer for thirty-one years. For a time, she lived on the street, and her husband, Frank Peterman Sr., practiced law there.

It was a time when people shared hardship and, most of all, bonding that has endured to this day, even though the neighborhood's people have scattered throughout the city, state and nation. In the summer of 2002, a reunion of the old 22nd Street community was held at St. Petersburg's Lake Maggiore. It drew hundreds. They came from all over.

Despite the community's strength, it could not fight the inertia of social change. Integration, the coming of the interstate highway and the reality of urban redevelopment fragmented the neighborhood and caused residents to scatter. Beginning in the late 1960s, a rougher, less family-oriented neighborhood began to emerge. For a time, the street's story was in danger of vanishing along with much of its community. People moved into neighborhoods previously off limits. Familiar old buildings were torn down. A sense of belonging evaporated.

The gains of the civil rights movement properly destroyed many of segregation's brutal and damaging ways. Integration often brought African Americans new opportunities in education, employment, housing and such routines of life as shopping, eating out and going to the movies. Ironically, the process also crushed some positive elements: a consistent sense of community and culture, a comfortable sense of connection and an appreciation of those who were pioneers in the struggle for the dignity that comes with self-determination. Most cheer the demise of Jim Crow restrictions, but the price for some has been the loss of a school, a tightly knit neighborhood, or simply that sense of place and belonging.

"Our young people now have to find their pride in other things and they can't always do it," was how Peggy Peterman expressed an unintended result of integration. "They're the generation that never saw the connectedness of the black community."

To be sure, nostalgia is not the best measure of history, and nostalgia has influenced memories of the old neighborhood. But at its core, 22nd Street was born of a difficult world based on restriction because of skin color. Its story tells of pride, perseverance and triumph over adversity. Twenty-Second Street symbolizes an African American cultural experience.

"Losing something like 22nd, the effects are damaging in terms of overcoming vestiges of racism," said Askia Aquil, a former president of the 22nd Street

Redevelopment Corporation. "Without it, there is no sense of community or sense of history. Artifacts, plaques, whatever, they help you maintain a connection to your community, to your history."

Perhaps some of the lost elements can be retrieved, and that is one of the purposes of this book, much of it created through the memories of people who welcomed a new day but recall with affection and respect a piece of the old.

STREET OF NEW HOPE
A Civil Rights Nerve Center

Sweet are the uses of adversity, which, like the toad,
ugly and venomous, wears yet a
precious jewel in its head.

— William Shakespeare, *As You Like It*

In south Georgia, not far from Plains, Joe Savage grew up picking peanuts and cotton. It put muscle on him, and the relentless sun made him tough enough for one of the hardest jobs any man could do in St. Petersburg, Florida: picking up garbage.

Savage moved to the Sunshine City in 1950 when he was twenty-five years old. He grew familiar with 22nd Street South. He became a "garbage man," hoisting thirty-gallon cans, two in each hand, and tossing the mess into cardboard boxes that were emptied into trucks.

For that, the city government paid him sixty-seven cents an hour.

It was a job and often, men couldn't afford to quit. Sometimes they worked well into their sixties, and there were stories of them dying on their routes. Savage wanted change: better pay, better working conditions. First he tried negotiating with city management. He led a couple of short strikes. When few changes resulted, Savage tried a different way starting in May 1968.

By then a cigar-chomping, hymn-singing workers' champion, Savage led 211 men, most of them black, on what became a 116-day walkout. Mountains of uncollected garbage piled up in a city of 200,000.

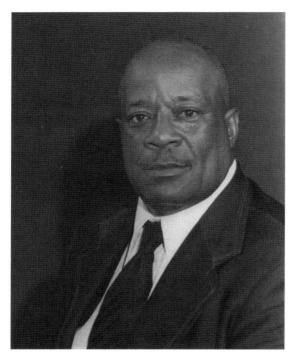

Joe Savage in 1968 led the city's sanitation workers in a four-month strike for better wages and working conditions. He was about sixty years old in this photo, and soon to retire from his city job. *Courtesy Clara Woodard.*

Twenty-Second Street South, where the Ku Klux Klan had paraded a generation earlier, now echoed with the tramping boots of hundreds of workers and their supporters on the way to City Hall. A.D. King, the brother of Dr. Martin Luther King Jr., slain a few weeks earlier, joined the marchers. So did Ralph Abernathy, the former president of the Southern Christian Leadership Conference. St. Petersburg made national news.

As the heart and soul of St. Petersburg's segregation-era African American community, it was logical that 22nd Street South would become the nerve center of the city's civil rights movement, which began to grow in the 1950s.

Respected professional men, whose houses and businesses were on or near the street, began pushing the envelope of segregation, hoping to break out of the restrictive housing and social patterns that closed most of the city to people of color. Dr. Robert J. Swain, for example, in 1954 successfully challenged a long-standing city tradition—it had no force of law—that kept black people from moving south of 15th Avenue South.

At the same time, grassroots activism began to grow. In such 22nd Street spots as Joe Yates's barbershop, the Shag restaurant and the S&S Market, proprietors and patrons talked about the 1954 Supreme Court decision that

promised to open public schools to all children, regardless of race. Despite that decision, the county school district built nine all-black schools between 1954 and 1963. Clearly, the freedom movement had its work cut out in St. Petersburg, as it did elsewhere.

"The strike in 1968 energized the city. I think that no other incident had as much effect as the '68 event. Maybe I'm being prejudiced. I think history will speak for itself," said Abdul Karim Ali, one of Joe Savage's sons. Savage was president of an organization called the Young Man's Progressive Club, an informal sanitation workers' brotherhood. They often would meet before marches in churches a few blocks off 22nd. The men would put on recordings of Martin Luther King's "I Have a Dream" speech, turning up the volume until the walls shook.

The strikers, led by Savage, marched on City Hall more than forty times, usually starting from the Jordan Park Community Center a block west of 22nd. Helmeted police confronted the marchers. The workers were fired and Savage was arrested. Remnants of white supremacist groups muttered about staging demonstrations of their own.

As the strike stretched into August, four days of violence shook black neighborhoods. But unlike other cities during a summer of national unrest, no one died in St. Petersburg, and Savage and the men he led were not widely viewed as the cause of the violence.

"As things developed, I would say his influences were very positive," said Don Jones, St. Petersburg's mayor at the time. "He was never an advocate of violence, to the best of my knowledge. He was a leader. He was leading from conviction and a sense of responsibility."

When the walkout ended, Savage and the other workers returned to their trucks, having won small concessions. They also, probably without knowing it, provided a boost to the freedom movement in St. Petersburg.

"There were a lot of places that weren't really integrated before the strike, like in downtown," said Frederick Douglass Winters, who was a sanitation worker during the strike and who became head of the union that represents the workers. "There used to be a mentality that places were off-limits. There were a lot of places we didn't go. But the strike kind of encouraged people to start to venture out," said Winters, who is named for the nineteenth-century African American abolitionist.

Black and white leaders began talking regularly to one another through the Community Alliance, a biracial forum organized soon after the strike. The city government, at least in small ways, began reaching out to black neighborhoods and housing and civil improvement programs began.

Even before the landmark strike, doctors, ministers, educators, lawyers and students had begun embracing the civil rights campaign. They sat in at lunch counters, welcomed and sheltered Freedom Riders when they visited St. Petersburg, worked to integrate city beaches and swimming pools, and—with the "deliberate speed" invoked by the high court's *Brown vs. Board of Education* ruling—began to pry open the doors of segregated schools.

By the turbulent 1960s, the 22nd Street community had become a crossroads and a haven for activists both local and national. Its evolution from a circumscribed, oft-dismissed neighborhood to a political pocket hot with passion was striking. The NAACP, the Student Non-Violent Coordinating Committee and the Congress on Racial Equality—among the era's premier civil rights organizations—had small storefront offices on 22nd. When national firebrand Stokeley Carmichael came to speak, a crowd gathered to listen at the Sno-Peak, the venerable drive-up chicken and burger restaurant across from the Manhattan Casino. Organizers strung an extension cord from Harold Davis's barbershop a block away to an amplifier in the broad Sno-Peak parking lot, where Carmichael talked for an hour.

Perhaps the most influential group in the city's earlier days of civil rights advocacy was the Ambassadors Club. Comprising many of the city's most prominent African American men, the Ambassadors became a consistent thread in St. Petersburg's history during the last half of the twentieth century.

Dr. Ralph M. Wimbish founded the club in 1953. He had been forced to put his swimming pool in his front yard because the city would not permit the building of his home nearer the north side of 15th Avenue South, the customary demarcation line between black and white residential areas.

Wimbish decided the time had come for black citizens to do something "within the system" to improve their circumstances. He invited several black professionals, educators and businessmen to his home. Adamant, energetic, enthusiastic, he challenged them: "Gentlemen, let us wake up and do something to help our community."

His words fell on receptive ears and the Ambassadors Club was born. Its other charter members were Dr. Orion Ayer Sr., Dr. Robert J. Swain, Dr. Fred Alsup, Samuel Blossom, Sidney Campbell, George Grogan, John Hopkins, Ernest Ponder and Emanuel Stewart. Wimbish, Ayer, Alsup and Swain had offices on 22nd Street. Grogan taught at all-black Gibbs High School, managed Jordan Park's public housing a block west of the street and was the man who turned the Manhattan Casino into an entertainment center. Hopkins, Ponder, Stewart, Blossom and Campbell were educators.

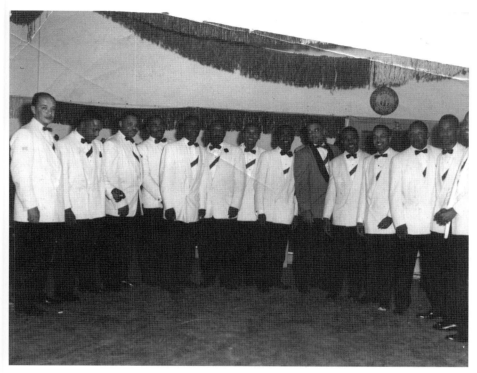

Shown at a Christmas dance at the Melrose Park Clubhouse, the Ambassadors Club played a major role in advancing civil rights for people of color in St. Petersburg. *From left:* Dr. Orion T. Ayer Sr., Sidney Campbell, Dr. Robert J. Swain, John Rembert, Samuel M. Robinson, Richard Smith, Ernest Ponder, Louis W. McCoy, organizer Dr. Ralph M. Wimbish, Fred W. Burney Sr., Leonard Summers, John Hopkins, Emanuel Stewart and Samuel Blossom. *Courtesy Mordecai Walker.*

Under Wimbish's visionary leadership, the organization quickly evolved as a civic and service club of distinction with the purpose of improving cultural, economic, educational and living conditions primarily in the African American community.

Immediately, the club began chipping at the walls of segregation. In 1954, it persuaded the Festival of States committee to include for the first time an African American float in St. Petersburg's annual showcase parade. On it were several young African American women, including sixteen-year-old queen Rosa Holmes, crowned at an Ambassador-sponsored coronation ball during festival week.

"We, as a group of African Americans, thought we'd like to show off some of our pretty girls just like the white clubs showed off their pretty girls," said Stewart, who coined the Ambassadors Club name.

During the 1920s, the Ku Klux Klan sponsored and rode on festival floats in their hooded regalia, symbolic of the city's dominant segregationist attitude. But despite the strict social codes, there were always occasions when black people and white people interacted on levels beyond the personal in community settings. The Festival of States, at least by the 1950s, was one of those occasions. The Gibbs High School band had marched in the parade for several years. Whites and blacks alike vigorously applauded the Marching Gladiators. The parade "drew a lot of our people downtown, and it created some interest in our society and community," Stewart said. He said parade organizers had no trouble accepting the Ambassadors Club's float entry.

"They had no trouble at all when they found out it was first-class and not something thrown together," said Stewart, a former Gibbs High principal and later administrative services director for the entire Pinellas County school system.

Rosa Holmes Hopkins, the queen of the float, remembers the parade vividly: "It was the most wonderful thing that has happened to me and my children." She remembered that the float was warmly received along the route by blacks and whites alike. "All along I had just a wonderful time." (Holmes married the late John Hopkins Jr., whose father was the educator for whom a St. Petersburg middle school is named. It stands on the site of 16th Street Middle School, once an all-black junior high in the segregation era. The new school serves youngsters from all over the city.)

Ambassadors Club member John Rembert, Gibbs principal in 1954, sponsored the high school junior. He made arrangements for Holmes to shop and buy her gown at Ruth's, an exclusive Central Avenue store in the heart of the segregated downtown business district—yet another suggestion that segregation, while a strong and consistently present force, did not rule every aspect of city life.

The Ambassadors Club reached beyond the African American community. In 1954, it honored its first citizen, Jennie L. Hall, a white woman who donated $25,000 to build a swimming pool, still used in 2005 at the Wildwood Community Center, a longtime leisure and sports complex in the black neighborhood near 22nd Street. A 1954 newspaper photo showed Hall posing with a young lifeguard named Ernest Fillyau, who later became an Ambassadors Club member.

The Ambassadors were founded "to work within the system" for civil rights, said Mordecai Walker, one of the early members. The club met with political candidates and white officials to make headway, said Walker, a retired educator who has been club president several times since he became a member in 1956.

Dr. Ralph Wimbish integrated the downtown Maas Brothers lunch counter in 1961. *Courtesy* St. Petersburg Times.

But sometimes club members didn't hesitate to take its message to the street and the lunch counters. Ambassadors Founder Wimbish was among those who helped integrate Spa Beach and other downtown swimming spots. Said Emanuel Stewart: "I do recall marching down at Webb's City. Although [owner Doc] Webb depended a great deal for his survival on blacks, he would not serve blacks at his lunch counter." Webb's City was called the "world's largest drugstore," a giant downtown retail enterprise that enjoyed a half-century run in St. Petersburg before the era of shopping malls.

Ralph Wimbish was perhaps the first African American to integrate a Howard Johnson's lunch counter on U.S. Highway 19, and he made a point of eating at the downtown Maas Brothers department store. Stewart challenged lunch counter segregation at a Grant's store at the Central Plaza shopping center. He said he sat down, ordered a full meal, ate, paid and departed with other customers paying him no attention.

Ambassadors Club members did what they could to make life easier for both the small and the mighty. Professional baseball players of color, who often enjoyed powerful cachet in Major League cities, could not stay in hotels with their white teammates during spring training in St. Petersburg. Swain and

Wimbish played host to some of the players with the New York Yankees and the St. Louis Cardinals. On a more grassroots level, the Ambassadors sponsored free lunches and milk to needy school children of all races.

As the club grew, it took pride in the accomplishments of its members. In 1982, the late Douglas L. Jamerson Jr. became the first African American to represent Pinellas County in the Florida House of Representatives. In 1984, he was appointed Florida's fourth commissioner of education. A new St. Petersburg elementary school bears his name.

The Ambassadors also helped others along the road to success, often focusing on education. Gibbs Junior College was a segregation-era facility for African Americans, but the club decided in 1961 to promote integration of all-white St. Petersburg Junior College, founded in 1927 and considered one of the nation's finest two-year colleges. The club chose Rosalie Peck, this book's co-author, as one of the two students who would lead the challenge. The other was Frankie Howard.

Peck has likened her experience to choosing a "road less traveled" that "has made all the difference," words made famous by poet Robert Frost. She was the last of ten children born to civic-minded parents who believed strongly in education. With her grandmother acting as midwife, Peck was born at home on 10th Avenue South and 25th Street. She grew up in the neighborhood, became an excellent Gibbs High School student and, as a young woman, attended Cortez Peters Business College in Washington, D.C. She said she was not surprised to be drafted as an educational pioneer.

Here is her account:

> It was a scary time. It was a time of mixed emotions: pleasure at the club's confidence in me; elation at the prospect of realizing, finally, my parents' desire for me to have a college education and my own lingering ambition to have achieved the same. I experienced intense and general anxiety regarding the whole process, but the first step—saying yes—was the easy part. I agreed without hesitation to face the challenge. Anxiety emerged and increased with the thought of applying for admission. Fear emerged and grew with the prospect and reality of possible danger. But coupled with a façade of bravado and a shield of denial, and braced with a goal-directed armor of obligation, pride and determination, I grew stronger.
>
> Then a different fear arose in my sleepless, anxious days and nights. There would, of course, be an entrance exam. Always an avid reader, I was not too worried about the general test. But Math! Algebra! Isosceles triangles! And, heaven forbid, word problems! (That part of math which to this day I don't understand.) Solving any such problem for me would be equal to walking on

Tampa Bay at twilight in a hurricane. My fear in this arena and many others was palpable. What if I failed?

To this day, those are the fears I remember. I clearly recall the worry and restless nights preceding the process. Fortunately, with the supportive understanding and encouragement of two friends, Edith Alsup and Bette Wimbish, wives of doctors Alsup and Wimbish, who were the primary participants in my dilemma (from which there could be no turning back), I followed sage advice. "Call Sally," they said. "She'll help you."

Sally Davis, a teacher and wife of Harold Davis, a 22nd Street barber and member of the Ambassadors, readily agreed to tutor me in math at their home several evenings a week. Even so, I was one of those people who freezes on tests no matter how well prepared. I was a nervous wreck as exam day approached.

I do not recall anything about the day of the entrance exam except being there. Sitting in the cafeteria (with other would-be students, all white) waiting for the exam to begin. To say I was tense would be a huge understatement. I was one breath this side of panic when I looked up to see someone I knew, a young woman who worked there. She nodded and smiled as if to say, "Don't worry, Rose, you'll do just fine." After the exam I drove directly to my mother's home, needing her reassurance. She was very proud and said so, adding, "Don't worry, baby, I'm sure you did just fine. And your Pa would be so proud of you, too," she said of my father, who died the same year as the Brown v. Board of Education decision. All my life, as had my mother, he had instilled in me the belief that I could do anything I set my mind to do.

I recall driving home to await long days and nights of hope and wondering, had I passed or failed; knowing instinctively that either way, the real test for my life still lay ahead.

Passing the test, as it turned out, was the easy part. What followed would determine the diverging roads and the path my life would take from that moment on. So on a quiet, peaceful, balmy summer evening in 1961, profoundly alone and apprehensive, yet filled with awesome excitement and a sense of purpose, I drove to St. Petersburg Junior College (now St. Petersburg College) and parked on 5th Avenue North across the street from the campus. No one was in sight. A long line of cars hugged the curb in front of and behind my car. There was no moving traffic, no breeze or sound.

Upon reaching the social science building, I climbed stairs to the second-floor landing where I tripped and fell. Dr. Michael Bennett, the college president, was standing there. Graciously, he helped me to my feet and directed me to the classroom where Dr. William Bierbaum, psychology instructor, without effort

or fanfare acknowledged my arrival with a warm smile and a casual gesture toward a seat, and proceeded to conduct the class.

Almost every seat was taken. Every student was seated and attentive. The atmosphere was pleasantly casual and conducive to the classroom work that was about to begin. My presence caused no stir. The students, all young, were neatly dressed and apparently relaxed. There were no hard or hostile stares, no tale-telling sounds, no sense of my being in any way different or the object of calculated invisibility. I saw no disapproving facial expressions or negative looks when eyes met. Without delay or showy gesture, Dr. Bierbaum began his teaching.

The subject was music and its effects on human emotion. Dr. Bierbaum included me in the discussion. I participated freely. He commented on my responses and said good night when class ended.

I left looking forward to the next class and most of all to the continuation of the path I had taken. I left class that night with the certain feeling that psychology was the field of study I would like to pursue toward a degree. But more than that, I left class that night with an overpowering feeling of quiet satisfaction, exhilaration and hope. Not just for myself, but for black children so dreadfully denied such basic rights for so many years. My thoughts embraced the youth of that time and those yet unborn.

I was filled with gratitude that my mother had lived long enough to at least see the dawning of the day that she and my father always said would come. (Although they warned everyone with ears to hear that integration, although a much-needed thing, would come with a price.) Much will be gained, but much will be lost, they said. They spoke from the experience of their years and the gift of prophecy. Having themselves suffered the sufferings of a people who alone can know the pain of apartheid as a way of life, they lived in hope for the inevitability of change while fully aware of the meaning of Kahlil Gibran's words: "As the seed must break to expose its heart to the sun, so must you know pain."

Within this context had I been born and reared to seek the higher good and to be ready when change long hoped for came.

I remember the joy I felt at being in college at long last. I was fifteen years past graduation from Gibbs High School (where our science class made do with five Bunsen burners, used books with missing pages and hand-me-down athletic togs and uniforms). Change was coming in St. Petersburg for every child wanting an education. I felt no special feeling of joy at being the first black female student at St. Petersburg Junior College. My joy was boundless because in my heart I always knew that's the way things should be and because I was reared by progressive-thinking parents who brought me up with assurances that

"a change is gon' come," and that it was my responsibility to myself to be all that I could be; to never give up and to be no one but myself. And so, as a student foremost, and secondarily as the first black female student to attend this esteemed institution of higher learning, I was in my element.

I remember another impressive night of Dr. Bierbaum's teaching. The subject was normal and abnormal behavior in humans. I was greatly impressed by the subject matter as well as the instructor. It was through such a class that I learned another profound truth: "An oyster with a pearl in it can be considered to be abnormal; however, this is not so because any normal oyster will develop a pearl when irritated by a grain of sand in a certain manner. All behavior is normal for the conditions which cause it."

These are words in a letter from Dr. Bierbaum, one of three written between the time I withdrew from St. Petersburg Junior College in 1961, lived in Nassau, Bahamas, matriculated to Bethune-Cookman College and graduated from Atlanta University with a master's degree in social work in 1968.

Three letters of support and encouragement from this St. Petersburg Junior College professor, who through his kind humanity, support, inspiration, professional dedication and academic talent made the awesome challenges of a young black woman facing a scary time of crossing the threshold of social and civic change at a time when, on a very personal level, "two roads diverged in a yellow wood," greatly enabled me to choose the road less taken.

And truly, that has made all the difference.

STREET OF ALL STORIES

A Community unto Itself

Until the lion writes his own story,
the tale of the hunt will always glorify the hunter.

—African Proverb

Jesse Henderson opened a sundries store at 22nd Street South and 9th Avenue about 1950. It was across from Harden's grocery, and its booths, jukebox and milkshakes created an archetypal, mid-twentieth century teen soda fountain. Just a block or two in either direction from a beer garden or nightclub, this hangout nonetheless was a world away from adult amusements.

"It was basically Jughead and Veronica," said Moses Holmes, referring to characters in the teen comic strip *Archie*. Henderson served malts and sodas across a counter running the length of one of the walls. Young people sat in booths and exchanged the latest gossip from Gibbs High School and 16th Street Junior High. The place was packed when Gibbs's homecoming parades twisted through the neighborhood. Henderson might play a few licks on the guitar. A nickel in the Rockola jukebox—sometimes the kids called it a "pick-a-low"—brought forth the mellow sounds of groups like the Orioles, harmonizing "Is It Too Soon to Know?"

"It was not a rowdy place. That part of 22nd was almost designated for teens," Holmes said.

Up the street, John "Geech" Black worked his barbecue magic, building his stand on the 800 block into one of 22nd Street's memorable

establishments, equal to the Manhattan Casino, Mercy Hospital or the Royal Theater. Students skimped on their lunch money so they could pay a visit to Geech's after—even during—school hours. Late-night revelers leaving the Manhattan Casino grabbed a pig-meat sandwich, spiced with Geech's trademark yellow sauce. Black used oak to build his fire. Former residents in town for a visit made a point to stop by, sometimes buying a batch of sandwiches to take home on the plane. The barbecue, even years later, has a reputation as being one of a kind. Black is said to have taken its recipe to his grave.

Black began cooking as early as 1930 in front of a grocery store he owned on 22nd near Fairfield Avenue, and through the years, he became one among dozens of people who helped create a rich and vibrant life along this cultural thoroughfare. The historic buildings are often recalled as a measure of a community, but it was the flow of humanity that pushed the heartbeat of 22nd Street.

Evander Duck and his wife Beverly, longtime residents of St. Petersburg but originally from New Jersey, remember the time when Springfield Avenue in Asbury Park was "the place" for black people, as was 125th Street in New York City. "Where black people were concerned in those days," Duck said, "the story of 22nd Street is universal in the history of the United States. One way or the other, every city had its own version of 22nd Street and the Manhattan Casino. East, west, north and south."

Said Constance Samuels, who grew up in the neighborhood during the 1940s and '50s: "It brought so much joy into our lives. We looked forward to meeting there, on 22nd Street. People just had fun."

Indeed, the street became a kind of social center. Like Grand Central Station, touted as the "Crossroads of a Million Lives," 22nd Street, on a monumentally smaller scale, also had its share of lasting relationships born through fate.

As teenagers, Annie Jewell and Freddie Dandy strolled hand in hand down the street during the 1940s, oblivious to everyone but each other. Together they attended Thursday evening dances at the Manhattan Casino, dancing to the music of Fess Clark's band, and they were regulars when the big, out-of-town groups came to play.

As youngsters, the couple enjoyed ice cream cones and sundaes downstairs at Kilgore Drug Store and were familiar with Dr. William F. Dicks, the white physician whose adjoining office was separated from Annie's house by a sidewalk that ran between the Manhattan and Jordan Court, where Annie lived as a child. Freddie lived a few blocks east of 22nd, on 19th Street South and 7th Avenue, within hollering distance of Annie's house.

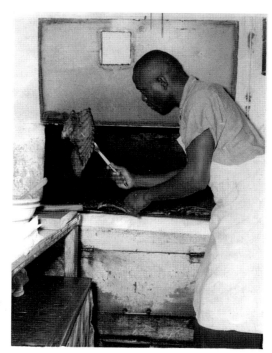

In this late 1950s photo, John "Geech" Black turns out some ribs in his barbecue stand's kitchen. *Courtesy Norman Jones II.*

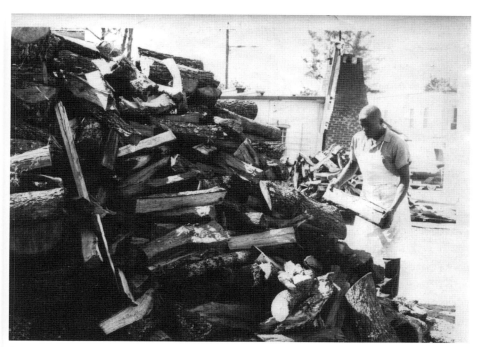

Geech tends to the oak woodpile behind his legendary barbecue stand. *Courtesy Norman Jones II.*

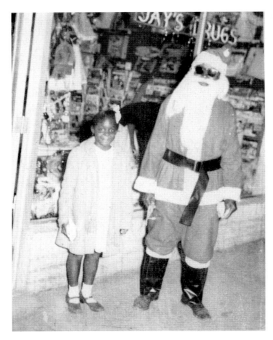

Seresa Woodard poses in 1956 outside Jay's Pharmacy with black Santa Claus Ernest Hill, a deliveryman for the pharmacy. Jay's Pharmacy was situated at 775 22nd Street South, near El Rancho restaurant and Ernest Fillyau's photography studio. *Courtesy Eunice Woodard.*

This was during the time when 22nd Street was to strolling what Campbell Park on 16th Street South was to picnics and Easter egg hunts. Strolling for the pleasure of it was a form of relaxation and recreation for black people of all ages. Everybody did it. For Freddie, who became a baker, and Annie, it was the prelude to a marriage that lasted sixty-one years until Freddie's death in 2003. They met as children at Jordan Elementary School, two blocks west of the busy corridor where their lifelong romance began.

Annette and William "Bill" Howard's paths crossed by chance when she was new in town, a recent arrival from North Carolina and living "on premises," which was the term used when a domestic worker lived on the employer's property. Her employer lived in the North Shore neighborhood. During an afternoon off, Annette ventured with two friends onto busy 22nd for a stroll. "Who is that?" she asked her friends, spying Bill across the street. The young women didn't know, but wasted no time finding out.

Bill and Annette encountered each other on a subsequent stroll. He asked for a date. She accepted. She got dressed up and waited on the porch for him. He did not show up. At the next encounter, he explained. Bill knew something that as a newcomer Annette did not: Annette worked in a part of town off limits to black people. He was not about to venture there after dark. He went to the dog track with his sister, Betty, instead.

Annette was off-duty for a half-day every Thursday. And every Thursday, like clockwork, she and her friends made a beeline to 22nd Street. They rode the bus from the North Shore section, where all worked for white families, to the Gas Plant area. From there they hitched a ride to 22nd Street where they strolled, stopped by Geech's for barbecue, went to the Royal Theater, ate at Walter Moten's Rendezvous restaurant, or sat on cars at the Sno-Peak, nibbling deep-fried chicken gizzards and listening to Fess Clark's band pour sweet sounds through the open window of the Manhattan Casino across the street.

Annette's next encounter with Bill was in the Manhattan's grand hall itself. He asked for a dance. She accepted. "And let me tell you something! I'm telling you that man could dance. You hear me?" she said years later, reliving memories still fresh in her mind. "And here I was, trying to keep up with him. It was great. The only thing was, he had to tell me he was the leader. And the rest is history."

In 2005, Annette and Bill had been married for nearly fifty years, during which time they purchased the former dental office and adjacent apartments of Dr. Robert J. Swain on the corner of 22nd Street South and 15th Avenue. The city designated the properties historic sites during the 1990s, a tribute to Swain's civic leadership and the fact that his apartments and his private home once housed such famous Major League baseball players as Elston Howard, Bill White, Frank Robinson, Curt Flood and Frank Barnes during the days of segregation.

Those who grew up in St. Petersburg during that era recall with vivid wisps of memory a tight community and its people, their places and their things—Easter brought out families to stroll in their Sunday best—Snow cones at Jordan Park Sundries and ice cream at the Sno-Peak—A barber named Oscar Kleckley who would cut kids' hair for free—Lincoln Bootery, where customers could run tabs—Johnny Swain, the butcher at S&S grocery who would wrap free meat when someone was hard up—Fireball entertainers Ike and Tina Turner staying above Buddy West's barbershop—Gospel and pop vocalist Sam Cooke at Jordan Park Apartment 274, gospel promoter Goldie Thompson's home—Cooke becoming godfather to Thompson's daughter, Ann—Thompson's daily radio spiritual hours, "The Old Ship of Zion" and "Peace in the Valley" on Radio WTMP—Characters like TV Mama, a homeless woman who pushed her belongings in a cart—Arthur Johnson, said to be so peculiar and powerful he could (and sometimes tried to) throw a brick around a corner—Sammy "Big Head" Thomas, who usually required the efforts of a half-dozen police officers if he decided to get rowdy; another tough one was a gentleman known as City Earl (he and Thomas never fought it out because the two had mutual respect)—

The "secret" passageway alongside the Royal Theater, leading from Jordan Park to 22nd—James Henry Bonner, who paid by the pound for old clothes and went through the neighborhood calling, "Rag man! Raaaag man!"—George Jones's state-of-the art service station at 13th Avenue, with its hydraulic lift—Henry Jones's station a few blocks away at 1900 9th Avenue South—Roosevelt Bennett, a tailor on 22nd across from Buddy West's barbershop in the 600 block—Roy Jones's liquor store at 11th Avenue—Handy Abrams Sr.'s beer joint at 7th Avenue below the Amvets Club (operated by Dr. Robert J. Swain with Richard Smith and Ernest "Cookie" Harris as managers)—and Richard Smith Sr.'s (with wife Annette, and son, Richard Jr.) income tax office at 9th Avenue.

The late Norman Jones Sr., a publicist, journalist and political columnist who for a time had a 22nd Street office, described in the 1960s African American communities as diverse neighborhoods in which people of various social statuses lived shoulder to shoulder; the churchgoers might step cautiously around the gambler on their way to the pews, while the teacher, the householder, the businessman and the tavern keeper all lived close by the doctors and lawyers and undertakers.

So it was on 22nd Street. Privately owned homes were sandwiched between business establishments and rooming houses and courts. Mr. and Mrs. Arthur McGhee, and their daughters Willie Pearl, Picola, and Allene (elected Gibbs High School's cutest girl for five consecutive years), lived near the Manhattan Casino building. Gussie Whittaker, a fifth- and sixth-grade teacher at Jordan Elementary, lived in a bungalow across the street from John Sylver's shoe repair shop. In the same 900 block stood such diverse enterprises as the Royal Hotel, J.D.'s Smoke Shop, the Blue Moon beer garden and the Zion Temple Pentecostal Church.

Eugene Gordon Sr., his wife Mary Dolores, a nurse at Mercy Hospital, and their son Eugene Jr., lived next door to the hospital. Odessa Daniels and her parents lived in a large two-story house next door to the Gordons, where the United House of Prayer for All People now stands. Minnie Sellers and her mother Phyllis's house was across from George Jones's service station, while a few blocks to the north, near Sidney Harden's grocery store, were sisters Mary Lou and Emma Lee Williams, and a friendly neighbor woman known as "Miss Lettie," who made the daily trek up and down 22nd to and from her job at the Soft Water Laundry.

Bars and poolrooms caused many parents to declare parts of 22nd Street off limits. For the age-eligible, there were at least twelve small clubs, areas forbidden to children, who understood they were to be home before dark.

Jacob Simmons, another longtime St. Petersburg resident, recalled the days of Prohibition, the Great Depression, house rent parties and moonshine. He

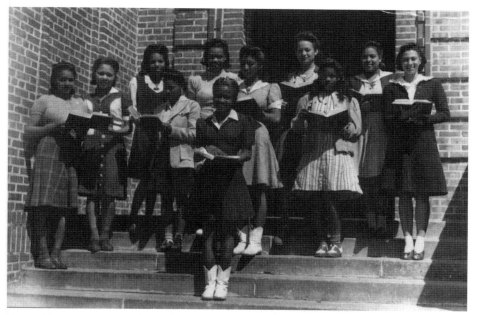

Many of the young women chosen the prettiest girls at Gibbs High School lived near the 22nd Street neighborhood. Shown here in 1942 are (from left) Serena Grant, Theo Peck, Helen McRae, Alice Bostic, Bettye Whitehurst, Minnie Martin, Anna Lou Curry, an unidentified young woman, Ethelyn Rose Harper and Joyce Carter Fillyau. In front is Allene McGhee. *From the private collection of Rosalie Peck.*

recalled that most bootleggers sold moonshine from their homes, that customers could buy a "shot glass" or a jar of the stuff for as little as ten cents up to a dollar, and that police raided a lot of dealers on weekends. Spots called "hot houses" afforded people the opportunity to drink and party after clubs closed.

Otherwise, 22nd Street was a haven. It offered courts—small, residential areas that formed a rectangle around a short street—apartments, hotels and individual housing. Many houses were modest, even ramshackle. Others were sturdy and substantial. Jordan Court, directly behind the Manhattan Casino, was built in the 1920s by Elder Jordan Sr.—one of his many enterprises. Sunshine Court and Magnolia Court, a few blocks east of 22nd Street, contained neat shotgun houses with shade trees and porch plants, occupied by beauticians, barbers, sanitation workers, cooks, tailors and other hard-working people and school-age children.

As a nine-year-old, Alvin Burns lived in Jordan Park. He and pal Charles Payne helped carry seats into the nearby Royal Theater when it opened in 1948. At about the same time, Burns picked up an old trumpet at Ira Harding

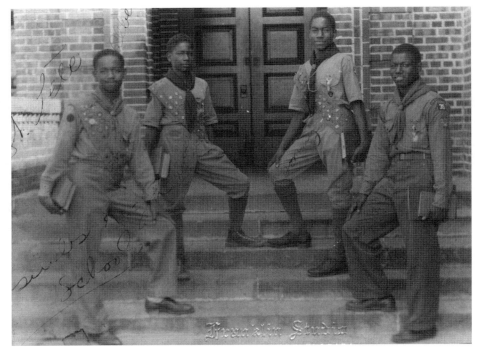

Developing youngsters has always been an important aspect of 22nd Street life. These Boy Scouts from Troop 35 were among the first in St. Petersburg to earn the Eagle rank, shown here about 1945. *From left:* Albert Allen, Gilbert "Sonny" Leggett, Thomas Moore and Clarence Edward "Shad" Williams. *From the private collection of Rosalie Peck.*

Wilson's home. Later, Boy Scout leader Charles "King" Tutson taught Burns the bugle. Burns studied trumpet under community music professors Reynold Davis and Sam Robinson. While playing at the Manhattan Casino with the Manzy Harris Orchestra about 1960, Burns met trumpet great Dizzy Gillespie. "He told me to practice and stay focused," Burns said.

Adults looked out for everyone's youngsters on 22nd Street. "I could walk down the street and have the possibility of being beaten by ten people for misbehavior," said Lou Brown, a realtor whose parents were educators.

Other authority figures were not always viewed as benign disciplinarians. White lawman Todd Tucker built a reputation of his own in the black community when he was a St. Petersburg constable. He was also the truant officer, feared by any little boy even thinking about playing hooky. Youngsters could terrorize their pals merely by shouting, "Here comes Todd Tucker!" It was enough to send entire groups into a dead sprint toward anywhere else.

Charlie Williams was among St. Petersburg's most intriguing personalities, black or white. Outside the law in some respects, Williams nonetheless remained part of the wider community in ways that might baffle people today. From the 1920s until 1953, Williams held an interesting niche in the free enterprise system. Besides his regular job as a railroad porter and his role as job broker for summer resort workers in the North, Williams was also regarded as the local boss of the mob-controlled illegal numbers racket, which resembled the modern era's state lottery and was based on the Cuban lottery. The police said he also ran a moonshine operation during the Prohibition era, but they never could pin anything on him. In 1937, a fifteen-officer raid at Williams's home revealed $50,000 cash hidden around the house, but no bolita tickets—the slips people used to record their chosen numbers.

If Williams was all he was said to be, he might have fit the profile of a breed of respected men and women as described by the journalist Jones, who wrote that African American bootleggers and gamblers, especially during the Great Depression, called political shots and controlled patronage, helped finance businesses and sometimes provided aid to the poor when government assistance failed. An extra-legal source could also provide money in a segregated economy in which traditional resources such as bank loans usually were unavailable.

Williams was widely known among both blacks and whites. Todd Tucker, a sheriff of the era who, during his years as a city constable, helped raid Williams's house, issued Williams an honorary deputy's badge. Authorities knew that Williams often carried a gun, but apparently ignored the fact. Because blacks could vote in St. Petersburg—despite periodic white primaries and intimidation tactics—white political leaders counted on Williams's influence with voters.

Williams was shot dead gangland style in 1953 while leaving a Ybor City barbershop in Tampa. More than three thousand attended the funeral at Bethel AME Church in Methodist Town, where Marie Yopp, the county's first African American public health nurse, assisted. Gibbs High School football coach N.L. "Love" Brown and three other Elks Lodge brothers sang Williams's favorite hymn, "Lead Kindly Light." U.S. Senator George Smathers and former Governor Fuller Warren sent wreaths. His murder was never solved though there was talk that Williams had become a government informant.

Not all the challenges people in the 22nd Street community faced were external, that is, connected to a segregated system's pitfalls. Sometimes people fought. There were stabbings and shootings, sometimes with fatal results.

In addition, the "north side/south side" stigma that physically and psychologically separated black and white people in St. Petersburg also affected attitudes of black children and grown-ups in interpersonal and negative ways.

Competition was fierce. Fights between north-side and south-side youths on the first and last day of school at Gibbs High were traditional. The motivation was based on one-upmanship and childish competition. North-side African American youngsters and adults alike disdainfully referred to the south side as "the country." South-side people "lived in the sticks," according to the chatter; south-side residents were "hicks."

It is ironic that some of the same friction existed between white residents of the north and south sides. For example, a middle-age white woman recalled in 2004 how, in the 1950s, a north-side cotillion committee wanted to withhold invitations to youngsters from families who lived on the south side.

There was no difference in the way segregation played out, but African American folks on the north side at least had street lights and sidewalks, whereas on the south side, many streets were not paved, kerosene lanterns lit homes and privies stood outside. On the north side, people lived near the La Plaza and Harlem Theaters, the South Mole swimming hole in Tampa Bay at the foot of 1st Avenue South, Bethel AME Church and the 10th Street Church of God in Methodist Town, and the hustle and bustle of Central Avenue with its array of shops, stores, goods and services.

In the early days of the 1920s, '30s, and '40s, it was relatively safe for people who lived far from 22nd Street and the Manhattan Casino to walk home late at night without fear of crime. Country darkness prevailed like a shroud. People walked over dirt roads, lighted only by the moon and stars, over sand beds and through palmettos. They were more fearful of meeting rattlesnakes than villains. Young men could be heard whistling in the night, returning to their cross-town homes after walking sweethearts and friends to their front doors.

Clarence Jackson lived in Jordan Park, a public housing project, during the 1950s. He recalled Jordan Park as a neighborhood where everyone looked out for each other. "You didn't lock your doors at night," he said. "You just went inside and slept."

Until the later 1940s, few people in the neighborhood had cars. Uriah Evans, a carpenter and well-respected resident of the area immediately west of the 25th Street side of Jordan Park, could be heard driving home at night in his black Model T Ford. Rosa Lee Bullard, a popular young woman who lived a stone's throw west of Jordan Elementary School and worked at the Soft Water Laundry, once sang (on a dare) with the Chick Webb orchestra at the Manhattan and drove a shiny green Chevrolet. Charlie Frank Williams, the son of Charlie Williams, was the only student at Gibbs High School with a car—a shiny, bright, yellow coupe that only enhanced his already well-established popularity with the girls.

All the car owners were among the fortunate, exceptional ones. Almost

everyone else walked, everywhere. But these three were role models, too. They were admired as well-dressed citizens, homeowners—or the children of homeowners—and possessors of nice cars. It was a time when the country was either in or on the verge of the Great Depression, and the accoutrements of success were encouraging to youth who, in their young, idealistic ways, not only day-dreamed of growing up and dancing at the Manhattan Casino, which everyone talked about, but dreamed also of one day being in a financial position to own homes, nice clothes and cars of their own.

Even getting to school could be a chore. Transportation for youngsters who lived a long way from Gibbs High was hard to come by. The county provided no bus service for black students. Dr. James H. Keys recalls riding from Methodist Town on the handlebars of Althea Harris's bicycle. Ralph James roller-skated to school.

During the 1930s, Manhattan Casino promoter and Gibbs teacher George Grogan pledged his teaching salary to help guarantee payments on the black community's first school bus. According to the Pinellas County school district's official history, *A Tradition of Excellence*, so did three others: Gibbs principal George Perkins and teachers J.K. Neal and Albert Brooks.

Nicknamed the "Blue Goose" because of its color, the vehicle was an old Ford Motor Co. bus with depleted power. Joseph Lovette Sr., a longtime Gibbs janitor,

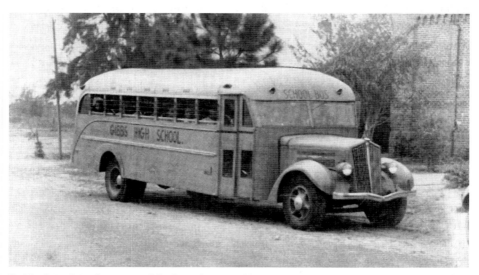

So black students from around St. Petersburg could have transportation to school, several Gibbs High School staff members pledged their salaries to purchase a used, somewhat decrepit bus. It was nicknamed the Blue Goose because of its color and was known for stalling on even gentle hills. *Gibbs High School yearbook photo from the private collection of Rosalie Peck.*

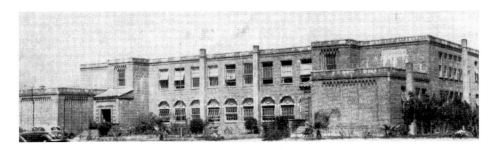

Gibbs High School, shown here about 1940, was originally built for white students and was about ten blocks from the 22nd Street neighborhood. *Gibbs High School yearbook photo from the private collection of Rosalie Peck.*

Despite inadequacies in equipment and textbooks, Gibbs High principals and teachers instilled in students a spirit of learning and a strong sense of affection for the school, seen here about 1940. It was named for Jonathan C. Gibbs, Florida's Reconstruction-era secretary of state and superintendent of public instruction. *Gibbs High School yearbook photo from the private collection of Rosalie Peck.*

drove the bus. Lovette picked up students on both the north side (Methodist Town) and the south side (the Gas Plant area and the 22nd Street community). Students paid a nickel to ride, and they, along with school faculty and staff, were responsible for keeping the dilapidated bus going. And dilapidated it was.

Keys, a 1943 Gibbs graduate, remembers the Blue Goose as so decrepit it could not climb 5th Avenue South—called Sugar Hill—without stalling. Boys got off and pushed it to an even plane so it could continue its route. Eventually two, then three newer buses replaced the Blue Goose. The county operated them and they served both the north-side and south-side black students. They were free to ride and were road worthy for sports events in other cities.

Despite the rules and regulations of segregation, black people consistently patronized white-owned downtown stores to get the latest items in fashion trends. Traditionally, for dances, churchgoing, teas, movies, football games, fashion shows or house parties, only the best and latest styles would do. Sam's Department Store on 22nd Street was popular for respectful treatment and convenience, but high fashion, one-of-a-kind quality and variety was the magnet that drew black shoppers to downtown stores, demeaning treatment notwithstanding.

Strict segregation was a way of life—spiritually hurtful and unacceptable, but steeped in reality. Within the system, unable to change things, black people endured, compromised and waited for the change that most believed would one day come.

Dressing up was important. Historically, from the quickly aborted days of Reconstruction that swiftly followed slavery, dressing well was a matter of great importance to African Americans. Whether going shopping or to church, one's appearance was not taken lightly. "First impressions count" was taught as a mantra. It was a way of life in terms of behavior as well as physical appearance— a cultural thing that came with freedom, a concept taught and reinforced from

Johnie Gonzalez Clarke (right) and her aunt Bessie Davis shopping on Central Avenue about 1960. Note the bag from Lane-Bryant, a downtown department store. African Americans could shop in some businesses downtown during the segregation era, but could not try on clothes. *Courtesy Eunice Woodard.*

St. Petersburg, Fla.
Season 1060

37

cradle to grave in most black homes and strengthened in schools and churches. Homespun, hand-me-down clothes went hand in hand with servitude and non-citizen, non-persona status. Its roots ran deep. Oppression could not kill self-respect in a race of people who could do little to change the situation but who at least could exercise choice when it came to presenting themselves to each other and the world.

Style-conscious black women and men of St. Petersburg shopped religiously at segregated downtown stores because being properly dressed was paramount to one's image, self-respect and pride. The pattern ironically guaranteed that black people would contribute significantly to the unbalanced economy through their patronage of the downtown clothing industry even though trying on merchandise was as taboo as drinking from water fountains, eating meals in downtown restaurants or sitting on green benches.

Consequently, a little tuck here or a little let-out there was often necessary to achieve a perfect fit. More than a few feet suffered from pinched toes and blistered heels from being stuffed into shoes too small. To that end, trips to shoe repair shops to have shoes stretched or otherwise remedied afforded limited relief, and seamstresses and tailors from 2nd Avenue to 22nd Street were always available to make required adjustments on ill-fitting garments.

For a race of people in St. Petersburg, times were hard during segregation at every conceivable level. Stifled people suffered. At one level, churches were packed on Sunday. "Tell me, how did you feel when you come out of the wilderness (leaning on the Lord)?" In bondage still they sang, their souls tested by time and circumstance but comforted by faith. At another level on a Friday night at the packed Manhattan Casino, Bobby Blue Bland stood crooning: "They call it stormy Monday but Tuesday's just as bad." Some of the same world-weary people swayed to the music, their spirits uplifted, their souls soothed through mutual understanding of pain unspoken.

All of it was part of the shared experience in the special, separate world of 22nd Street South.

STREET OF HISTORY
Born of Necessity

Injustice anywhere is a threat to justice everywhere.
—Dr. Martin Luther King Jr.

Through the years, civil rights leaders, educators, professionals, nightclub promoters and small business entrepreneurs left their marks on 22nd Street South. They transformed an obscure, woodsy trail connecting scattered houses and building-trade warehouses into a community lifeline crackling with the energy of a hot jazz band.

But in the beginning, Elder Jordan Sr. was the man.

Jordan pulled out of sandspur patches the makings of a town within a town. During the World War I years and into the 1920s, he became the pioneer black developer along 22nd Street South. Born a slave about 1850, Jordan knew what to do with freedom when it arrived. He became a successful farmer, tilling north Florida soil on a farm his family owned after the Civil War near Fort White in Columbia County. He was thrifty, by all family recollections, and when it was time to go somewhere else, Jordan took his money, his ambition and his drive. All of it ended up in St. Petersburg.

In 1904, perhaps having fallen afoul of white vigilantes, Jordan moved his wife and five sons to the dust-road town on Tampa Bay's western shore. St. Petersburg was still a part of Hillsborough County then.

The Jordans carried everything they owned in a wagon. At first, the patriarch, already in his middle fifties, got busy selling fruits and vegetables. He turned a

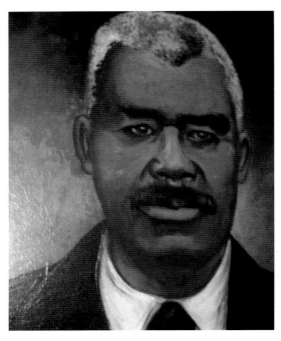

Elder Jordan Sr. came from north Florida to St. Petersburg, where he became 22ⁿᵈ Street's pioneer African American developer. This portrait of Jordan was painted by Gibbs High School art teacher Lewis E. Dominis in 1951 using a photograph. *Courtesy Joe and Ada Albury.*

front room in his house on 9ᵗʰ Street South into a virtual produce stand, recalled a granddaughter, Henrietta Causey. He made deliveries in a horse-drawn wagon, and he opened a livery stable.

Later, he started buying tax deeds, sometimes using borrowed money when he needed to. Some of it probably came from white people, from whom he earned respect as an independent entrepreneur. Some old-timers remembered that, in a turnabout, Jordan eventually loaned money to the city government when times turned hard after the stock market crash of 1929.

Jordan had ambition and the desire to build; his drive meshed well with city fathers' desire to establish a black community on what were the growing city's outskirts. He began to build wooden houses, grouping them in enclaves called courts. Ira Harding Wilson lived in one such house on Emerson Avenue as late as 2002, one of the last shotgun-style dwellings to survive in the 22ⁿᵈ Street neighborhood. Wilson said Jordan had built it in 1917.

Work crews literally hacked a neighborhood out of forest and field. "I recall riding aboard a horse cart going through the swamp, men carrying axes. They had high-laced boots to protect them against diamondbacks," said William Jordan, a grandson.

The Jordans made an exotic family, even for backwater St. Petersburg. Elder Sr. was a tall, imposing figure who liked to dress in black and sometimes wore

a cowboy hat. He was married to Mary Frances Strobles, a Cherokee who, at more than six feet, stood taller than her husband. She smoked a pipe and her dark hair was so long she could sit on it.

According to census records, the couple married on December 20, 1885, in Levy County on Florida's gulf coast. Mary Strobles was from Rosewood, a Levy County settlement that earned notoriety in 1923 when whites massacred blacks and burned most of the village.

Levy County and Rosewood historian Lizzie Jenkins said Native Americans played a large part in the establishment of Rosewood and speculated that Strobles could have been the daughter of an Indian and reared by a black family.

Jordan met Mary Strobles in a camp, remembered granddaughter Causey. "She was an Indian, a real Indian...I can remember plaiting her hair." Of Elder Jordan Sr., Causey said: "I never knew my grandfather to have a job. He was more of a real estate man. He bought property and sold it.

"When they came here, they saved their money and down off of 16th Street [South] and 5th Avenue, they owned a lot of property there. They had a filling station on the corner of 14th and 5th," Causey said. The family went to church at McCabe Methodist Church, 357 9th Street South.

The 22nd Street community Jordan boosted was not St. Petersburg's first black neighborhood. In 1888, African American laborers helped complete the Orange Belt Railway through central Florida all the way to the village that became St. Petersburg, first incorporated in 1892. The railroad workers founded a settlement known as Pepper Town, not far from the Orange Belt station but away from a cluster of white-owned stores.

Another neighborhood grew around an African Methodist Episcopalian Church. Called Methodist Town, it lay just west of 9th Street and ironically, a couple of blocks north of Central Avenue. Central forever has been the demarcation line between "north side" and "south side"—terminology whose racial overtones grind into the twenty-first century.

Still another community sprouted a few blocks south of Central, directly south of Methodist Town. It was a densely packed residential and business area with each court and enclave bearing its own name, but in general was called the Gas Plant because of two skyline huge cylinders that stored the city's natural gas supply.

As African Americans were pushed farther toward the city's edge, it was 22nd Street that became the lifeline, heartbeat and main street for St. Petersburg's African American population.

During the city's 1920s boom, recruiters scouted north Florida, Georgia and Alabama for labor to help build downtown hotels and new houses in

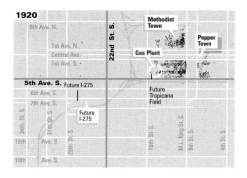

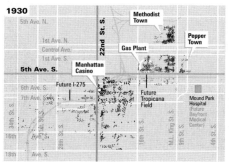

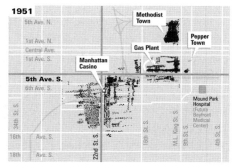

These maps dramatically illustrate the growth of 22nd Street South from 1920 to 1951, as well as chronicling the dense contraction of Methodist Town, the persistent growth of the Gas Plant area and the gradual disappearance of Pepper Town. The maps were plotted using Polk city directories, which until 1951 prefaced the names and addresses of St. Petersburg's black residents or businesses with an asterisk or the letter 'c' to designate 'colored.' It was a red-lining measure used to promote segregation. *Courtesy Don Morris,* St. Petersburg Times.

growing subdivisions. Though there were the black neighborhoods closer in, newcomers were directed to what was then the city's edge at 22nd.

During the hip 1960s, the street's double digits gave it a nickname, "the Deuces." Its ten-block-long core of black-operated businesses, professional services, entertainment hotspots and churches offered most everything a person required in a segregated society. You could be born in Mercy Hospital, buy groceries, clothing and furniture in any number of small stores, go on an after-school date to Henderson's soda fountain, choose a favorite beer garden, see a movie at the Royal Theater, consult physicians, dentists and lawyers, and, when life was over, be served by one of two funeral homes. People ate at Newkirk's Chop House, got their hair cut at Oscar Kleckley's barbershop and danced at the Manhattan Casino to the music of such all-stars as Buddy Johnson and Count Basie.

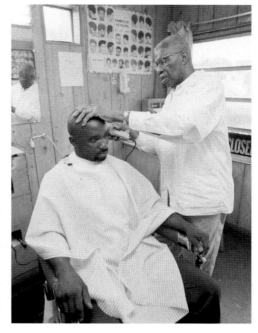

Joe Yates cuts a customer's hair in the barbershop he operated on 22nd Street from 1955 until 2001. It was among the mainstay businesses during 22nd Street's peak years. Yates and Euolia Fegans also operated the Jordan Park Nursery and Kindergarten from 1961 to 1976. *Courtesy* St. Petersburg Times.

During the late 1950s and early '60s, 22nd boasted more than 100 businesses, peaking at about 111 in 1960, according to records. Perhaps 75 percent were black-owned. African American communities developed as heavily concentrated sections because government and business drew lines around them for years. One such process was "red-lining," a race-based practice of steering people away from buying property or refusing to do business in certain neighborhoods. The 1931 city charter forbade blacks and whites to live or start businesses in each other's neighborhoods, though the provision could never be enforced consistently.

A 1936 city council resolution tried to move all African Americans into a single pocket south of Central Avenue. Though it proved impractical, the lines of segregation, with the government's approval, continued to be drawn. The dynamic helped generate all-black neighborhoods.

When people were pushed out or hemmed in, African American neighborhoods "grew out of necessity, the mother of invention, the need to provide goods and services for ourselves," said Askia Aquil, the former president of the 22nd Street Redevelopment Corporation, an organization dedicated to reviving the old main street.

The street meant more than convenience in a world with walls. It was a place where, for the most part, people took care of one another. On 22nd Street, stores,

services, and entertainment spots owned or operated by African Americans offered what often was missing in the white-dominated world: respect.

This was a time when being caught north of Central Avenue after dark was a crime. Gulfport, which developed originally as a white municipality south of St. Petersburg, was historically so intolerant that people of color made every effort to leave its boundaries before nightfall. When on occasion darkness fell before a hired hand could finish his work and leave the community, he was allowed to spend the night at the home of his employer.

Green benches that lined Central Avenue for respite and convenience of white citizens and tourists were sacred. But by strenuously enforced custom, they were off limits to black people, for whom terms such as "citizen" or "tourist" did not apply. Bushes and alleys had to serve as restrooms. Thirst had to go unquenched unless one happened to be in a place of business that provided water fountains marked "Colored." A sit-down meal was out of the question. A bite to eat could be had from certain arcade-type places that sold hot dogs, provided it was eaten as one continued on his or her way. To circumvent these indignities, black people ate before leaving home, reminded their children to make toilet stops, and drank little or no water in order to decrease the need for physical relief while "downtown."

Although shopping was allowed in the best of stores on Central Avenue, a few blocks from the black neighborhoods, there was no trying on of hats, clothes or shoes. Clothing sizes were guessed at and shoes were sold according to one's foot size drawn on a piece of brown paper—and with the understanding that no exchanges were allowed in the case of a bad fit realized when one got home.

"The Stockade," a formidable place of incarceration near the Harlem Theatre and the Gas Plant district, accommodated black men for the slightest offense. A racially biased police force complemented the omnipresence and omnipotence of the Ku Klux Klan. There were wild car chases, brutal beatings, hangings and first-hand understanding of the word terror. It touched every black man, woman and child in one way or another on an almost daily basis. Generations of St. Petersburg's youngsters, for example, heard the story about the 1914 white mob lynching of a black man accused of murdering a white man and raping his wife.

Henrietta Causey said she remembers Klan marches through black neighborhoods. "It was frightening," she said. "But our family, we never had to be bothered with that, because my grandfather was a man who taught us not to fear."

Elder Sr.'s courage served him well in north Florida. It also may have prompted his move to St. Petersburg. He tried to protect a young black man accused of

raping a white woman, said grandson William Jordan. The man had asked Elder Jordan to hide him. Vigilantes caught the man and lynched him, later paying a visit to the Jordan farm. "My grandfather came out with a shotgun and faced them down. But he knew that was it for him. He packed his family up," said William Jordan.

Once in St. Petersburg, Jordan and his sons built houses and rooming houses, operated a bus line and opened a beach for African Americans. They cleared land and helped open other businesses. Elder Jordan Jr., in 1925, built on 22nd Street's 600 block the fortress-like structure that became the Manhattan Casino.

According to city records, the 1925 building was originally meant to be apartments and a service station. But it became known as the Jordan Dance Hall, which eventually would become legendary as the home of the Manhattan Casino. It wasn't a gambling emporium; the fanciful name referred to the building's upstairs ballroom.

In some respects, Elder Jordan and his family were able to avoid some of the worst aspects of life under Jim Crow. Even so, William Jordan said jealousy on the part of some white people about his family's success drove some of its members from St. Petersburg. In a 1997 interview with St. Petersburg Times correspondent Susan Eastman, William Jordan said he and his mother left in the aftermath of a lynching. Fannie Mae Jordan hired a driver, packed her car and moved to Asbury Park, New Jersey. "She said she would never raise a child in a town like that," Jordan said. "I remember leaving at night, and I was so sad to go. But I really didn't know the reason why."

The Klan considered St. Petersburg a stronghold in the 1920s. Prominent residents belonged. Klansmen helped finance the first YMCA downtown, entered floats in festival parades and initiated boys into a junior auxiliary. They marched, burned crosses and flogged people who violated their racial and moral codes.

In the 1930s, a Klan march into the black community's neighborhood proved to be too much. A man named Charlie Williams stood up to the hooded order. A strapping fellow with a hearty way, he was a porter on Seaboard railroad trains like the Orange Blossom Special, which carried tourists from the Atlantic Coast. Williams also was a businessman, in the broadest sense, in the black community. Sometimes people who wanted to start businesses, including a few on 22nd, touched him for money. Williams was said to make plenty of his own through bolita, the illegal game in which people bought numbers and hoped to win a weekly jackpot. Various mob figures, including some among Tampa's Trafficante crime family, took turns running the lucrative racket on Florida's west coast. Newspapers regularly

referred to Williams as St. Petersburg's "bolita king." The city was considered his territory.

A prominent member of a state Elks organization, Williams also was a political activist. Politicians courted him, believing he could deliver black votes. In 1937, he urged African Americans to register to vote and back the police chief in a civil service referendum that might have paved the way for recruitment of black officers.

On election eve, more than two hundred Klansmen marched in hoods, masks and robes to scare African American voters. They gathered at 9th Street South and 4th Avenue, where they burned a cross. Newspaper reports didn't identify the Grand Cyclops, the Klansman leading the march, but they did record his comments: "This demonstration is in protest of the recent [black] registrations to kill the white vote, and of the rumored close connections of some of our high police officials with the [black] gambling element. This is a white man's city. Let's keep it that way."

The marchers went through black neighborhoods, stalking south on 16th Street to 9th Avenue South, then west to 22nd Street. Ira Harding Wilson, then in his teens, said he sicced a dog on them. Eventually, the Klansmen made their way to Charlie Williams's house at 1242 1st Avenue South, near the railroad tracks. They set a second cross ablaze.

According to enduring lore, Williams came out with a weapon. Some versions say it was a shotgun; others claim a machine gun. Some say he blasted apart the flaming cross, others that he simply faced down the Klansmen and turned them around. Newspapers of the day don't mention the confrontation.

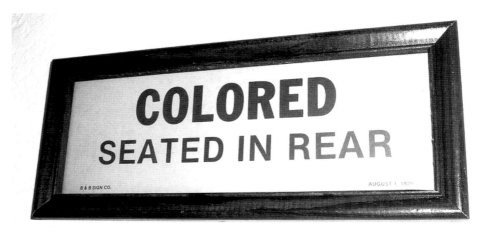

The sign, of 1929 vintage, was one among many Jim Crow directives posted in public places and conveyances. *Courtesy Gwendolyn Reese.*

The next day, black voters turned out in force. They were outvoted, but it was the last time hooded Klansmen marched en masse in St. Petersburg.

St. Petersburg, with its share of racial prejudice, segregation, injustices and strife in years past, was not unlike other Southern towns and cities of the same era. The social climate made significant differences in the lives of many black people in profound and memorable ways, affecting their education, the places they lived and worked, and their opportunities to advance.

There have always been white people in St. Petersburg, who, while benignly condoning the racist behavior of others, did nothing to add fuel to the fire. And there were those who, through direct intervention, helped, supported and rescued the oppressed. They sometimes were responsible for making the lives of black people easier and sometimes even saving them.

One prominent white man sat on the sun porch of his luxurious, white-neighborhood home at night, providing prearranged escape plans to any hunted black man he believed to be innocent of a crime. His identity remains one of St. Petersburg's best-kept secrets. Acts such as his formed the basis for such expressions as: "Things are tough. But not as bad as in some places." Such attitudes provided strength to the power of faith, the spirit of hope and the long journey toward a brighter day for all.

STREET OF MUSIC
The Manhattan Casino and the Entertainers

I don't sing a song unless I feel it. The song don't tug at my heart, I pass on it. I have to believe in what I'm doing.

—Ray Charles

After dark, and especially on summer nights, 22nd Street became a walking, rolling party—a river of people and a parade of cars. Heat lightning glimmered over Tampa Bay a couple of miles east and Geech's barbecue spread its aroma like hot perfume. Bands and jukeboxes belted music out of every doorway. Billiard balls clacked. People called out greetings, laughed, argued, talked business. "There was always something going on. Somebody out twenty-four-seven, let me tell you," said Bobby Bowers, whose family owned the Sno-Peak drive-in for more than fifty years.

The Sno-Peak, made of wood and always appearing a bit frail, never was a pretty structure. But it stood in a massive parking lot across the street from the Manhattan Casino, and besides burgers, fried chicken and ice cream, it provided a kind of outdoors auditorium for the people who couldn't get inside to hear the Manhattan's music.

More than any other enterprise, building or institution, the Manhattan Casino, nicknamed "The Home of Happy Feet," came to symbolize all that 22nd Street meant to African Americans during the segregation era. From the 1930s until it closed in 1968, the Manhattan was a place of good times and glamour, freedom and self-expression. It was a haven for

Nighttime at the Sno-Peak, one of St. Petersburg's oldest surviving drive-up restaurants. Back in the day, people gathered in its huge parking lot to hear music spill from the Manhattan Casino across the street. The Bowers family operated the Sno-Peak for more than fifty years. *Courtesy* St. Petersburg Times.

music lovers and an undisputed escape route from daily hardship and racial scorn.

Built in 1925, a half-block long and twelve thousand square feet, the Manhattan building through the years housed on its first floor a pharmacy, restaurants, a cleaners, a bar, a variety store, barbers and a post office, among other enterprises.

Upstairs, partiers in tuxedos and evening gowns danced to the finest musicians traveling what was called the Chitlin' Circuit, an informal nightclub route through the South. Ella Fitzgerald sang "A Tisket, A Tasket." James Brown screamed 1960s soul. At Sunday gospel hours, Mahalia Jackson praised the power of the Lord.

Sometimes the place was so packed—or so adult—that not everyone who wanted to could get in. Neighborhood children shinnied up to the second-story balcony, hoping to glimpse Louis Armstrong or Count Basie. Sometimes they tied together clothes to fashion makeshift ropes. Grown-ups shooed the children down, threatening to tell their parents, their grandparents and aunts. Everyone knew everyone else in the community.

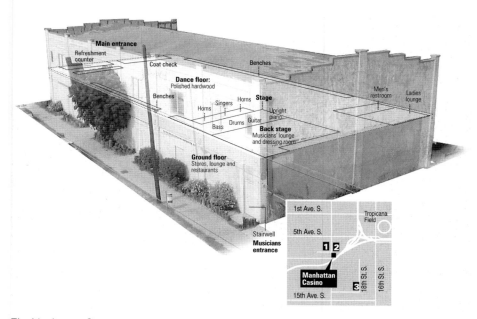

The Manhattan Casino was a community center, providing a venue for the era's best entertainers and gospel artists. It was also a social center. This is the only known cutaway view of the building's layout. The inset map locates the neighborhood's entertainment venues. *Courtesy Don Morris, St. Petersburg Times.*

Henrietta Roberts came to St. Petersburg in 1956 from Birmingham. A suburban building boom was luring skilled tradesmen and construction workers from Alabama and Georgia. "The women followed their boyfriends," Roberts said. She got a cashier's job at George Jones's grocery store on 22nd and 13th Avenue.

At night, she parked across from the Manhattan on the Sno-Peak lot, where the cars were hubcap to hubcap. "We'd sit and eat our sandwiches and drink our drinks and listen to the music," Roberts said. B.B. King's "Sweet 16" was her favorite song. Searing blues notes pelted out the Manhattan's open windows. Air conditioning was not common then, so the open windows and tall fans stirred a little breeze around the dance floor.

How the Manhattan Casino got its name remains a mystery. Originally, the building was called the Jordan Dance Hall when it opened, named for its builder, Elder Jordan Jr. Most believe promoter George Grogan renamed it. Lifelong St. Petersburg resident Al Williams, who played in one of the Manhattan's house bands, said the name derived from the idea of Manhattan in New York, not only for its romantic, big-city suggestion but also for its

George Grogan taught chemistry, managed the Jordan Park public housing complex and turned the Manhattan Casino into a musical venue for the era's best orchestras and entertainers. This 1940 photo was taken from the Gibbs High School yearbook. *Gibbs High School yearbook photo from the private collection of Rosalie Peck.*

symbol as a place where Southern blacks might migrate in the hope of escaping the bitterness of segregation.

Whatever the origins of its name, the man most responsible for molding the character of the Manhattan Casino was Grogan, the dapper promoter. He had lived in New York City and had connections there. A compact man usually dressed to the nines, Grogan was from Winston-Salem, North Carolina. After college, he went to the big city to study mortuary science, said Ira Harding Wilson, a longtime friend. Grogan got to know Ben Bart, who had the Universal Attractions agency in New York. Eventually, said Wilson, Grogan took over Florida bookings. Big-name musical personalities would play smaller cities between bookings in larger markets.

Grogan was a complex man who pursued many interests. He taught chemistry at Gibbs High School, while promoting the Manhattan's nightlife, usually off limits to most youngsters. He also found time to manage Jordan Park and sell real estate. "If you wanted to make money, George Grogan would tell you how to do it. He was a born promoter," Wilson said.

Grogan gave James Brown a start at the casino. The 1960s star rehearsed there and played every Thursday and Saturday until moving on to bigger venues and international fame. William H. "Buddy" West, a barber and a tailor,

THE SUB-DEBS
Invite you to be
their guest
On the Closing Night
Friday, May 31

at the

MANHATTAN CASINO
Ladies; Formal
Men; Semi-formal

The invitation documents one of the social functions at the Manhattan Casino. The Sub-Debs were a young women's social club. Its officers from 1944 to 1946 were Willie Mae Walton, president; Mildred Walker, vice-president; Millie Woods, recording secretary; Lola Mae Washington, corresponding secretary; Ruby Grubbs, treasurer; Louease Randolph, chaplain; and Bernice Randolph, reporter. *Courtesy Eunice Woodard.*

also promoted Manhattan shows in the casino's earlier days. He booked the Don Redmond Band as the first big-time group to play the casino, and he also is credited with bringing in Louis Armstrong, Fats Waller and Earl "Fatha" Hines. He also booked Duke Ellington to play at the Amusement Center, and in 1934—the first year he began to have an impact on 22nd Street—West arranged Thursday afternoon dances for young people, charging twenty-five cents admission.

Radio personality Goldie Thompson supplied another key element at the Manhattan, booking the era's best gospel singers. His trademark advertising slogan was, "Tell 'em Goldie sent ya!"

The dance hall also accommodated graduations, proms and other school-related activities, club meetings, teas, concerts and fashion shows. But in addition to its events featuring headline acts, the casino was famous for Friday night dances. The Manhattan Casino was the place to be.

It was the social gathering place for high-brow, low-brow and in-betweens. When it came to "music, maestro, please," the casino was black society's equalizer. High school students old enough to be let in danced, smiling at their teachers; parents danced side by side with their children's friends. Other teenage boys, too sophisticated to climb up to the back porch but still too young to attend, were turned away at the ticket booth downstairs.

Sturdy wooden benches lined each side of the long dance hall. Patrons climbed narrow wooden stairs, anxious to reach the second-floor entrance, where a refreshment bar, checkroom and greetings by friends and early arrivals awaited them. Fun, laughter and dancing ruled. At the dance floor's south end, a small bandstand was alive with musicians and vocalists filling the hall with pulsating, energizing music.

Behind the musicians were the orchestra room, restrooms and an exit stairway for safety as well as convenience for instrumental access to and from the building. There was usually a large gathering for local musicians. For big-name bands and orchestras, the place was packed. People by habit usually gravitated to the same seat, if available. If the space was occupied, all one had to do was wait for the person to leave the coveted spot for a dance. Many people, especially the men, spent a great deal of the night standing because seating was always at a premium. Some mix-and-mingle couples danced every round. Once in a while, women sat to relax their tired feet, easing the pressure of new shoes on sore heels and pinched toes, catching a breath and getting ready for the next dance.

Outside, music lovers sat in and on cars in the night air, hearing Clyde McPhatter, Lucky Millender, Cab Calloway or Otis Redding. Some were fans left out because the casino was standing-room-only when no more tickets were sold. Sometimes money was short and people couldn't afford the tickets. And some simply preferred listening to the music from a distance.

As far back as the Charleston and Black Bottom eras, to the night the music died in the late 1960s, generations of children grew up looking forward to the day when they could experience a rite of passage—the age when they could legitimately join the ranks of parents, relatives, neighbors, teachers and friends who long before had been regulars at the Friday night dances.

Co-author Rosalie Peck and her friend Eunice Smith Woodard at age sixteen were allowed entrance with chaperones: Woodard's aunt Johnie Gonzalez Clarke and her friend Alberta Staten Smith. Because both girls were under parental curfew and had to be home before midnight, they (sadly) had to leave the dance at intermission. Not until they turned eighteen were they allowed to go to dances with friends and stay until the end. It was an anticipated day for them to reach the magic age and be allowed to climb the narrow stairs to

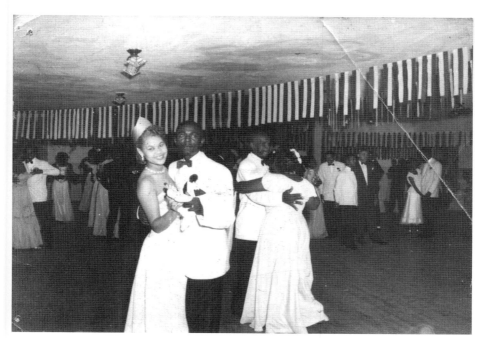

Rosalie Peck and Major Kelly dance at a Club 16 event at the Manhattan Casino. The couple in the background is Everette and Ella Mae Wallace. Club 16 was one of the city's leading men's clubs, and Everette Wallace was considered one of the best dancers around. *From the private collection of Rosalie Peck.*

dance. Young and old alike looked forward to the dances, whether the music was provided by Fess Clark, George Cooper, Manzy Harris or the Gibbs High Revelers, all local musicians.

For an entire week before a dance, excitement filled the air, especially with posters everywhere announcing the coming attraction that could be Sassy Sarah Vaughn. Or perhaps sensational Sister Rosetta Tharpe; Savannah Churchill, with her signature song: "I Wanna Be Loved"; Dizzy Gillespie, with his one-of-a-kind horn; Louis Jordan and his Tympani Five. Erskine Hawkins rocked the place with his "Tuxedo Junction" and Bull Moose Jackson rendered powerful, soul-stirring blues.

Sometimes, at the nearby Melrose Park Clubhouse, dances would be strictly formal affairs, featuring Count Basie or Duke Ellington. Other clubs included one called Joyland, just west of 22nd on Fairfield Avenue; and the Amusement Center at 22nd and 6th Avenue. Joyland had a skating rink, and sometimes the Amusement Center served as a venue for the Gibbs High School basketball team.

George Grogan promoted a few dances at Joyland, organizing Miss Fine Brown Frame contests, a kind of beauty competition that took its name from the song made popular by Buddy Johnson and his orchestra. He also promoted music and dances at the Amusement Center, a converted warehouse.

All the venues provided unforgettable evenings. But mostly, the skillful arrangements of Grogan provided the "Home of Happy Feet," the soul-satisfying entertainment center for black St. Petersburg during segregation. During that period, entertainment away from 22nd often was limited to the "crow's nest" section of the La Plaza Theater on downtown Central Avenue, the ill-kept confines of the Harlem Theatre at 1017 3rd Avenue South, limited swimming space at a beach on Tampa Bay called the South Mole, church picnics, social teas and house parties.

At the Manhattan dances, looking good was not an option; looking good was a foregone conclusion. Men showed up with fresh haircuts, pressed slacks, neat shirts and polished shoes. Women arrived with freshly shampooed, straightened hair attractively styled in waves, curls, bangs, chignons, pageboys and wigs. And of course, a new dress was nearly obligatory. Nails were manicured. Shoes and pocket books matched. Seldom was a woman seen wearing the same dress twice in succession.

Layaways at Willson-Chase, Rutland's, John Baldwin, Sherman's, Maas Brothers, Lane-Bryant, Slimer's, Lerner's, Miller's and Webb's City made looking good possible on a regular basis, budget notwithstanding. Perfumes were a must. The Webb City's perfume counter offered a generous array of attractive selections: Tweed, Evening in Paris or Chanel Number Five were dabbed behind feminine ears as finishing touches for another evening of dancing pleasure.

It was a time when old friends, casual acquaintances and strangers mingled and socialized unencumbered by the world outside. For a few precious hours, a segment of St. Petersburg's black population enjoyed relief from the reality of their stressful world. It represented another few hours to escape from the problems of racism, segregation and other forms of oppression. "Got to meet my mule in the morning" was a clever expression that carried several levels of meaning. But while the night lasted, the attitude was, "Let the good times roll."

Eunice Smith Woodard said she never failed to keep an eye out for a certain young man from Tampa whose name she has forgotten, but whose smooth dancing she will never forget. By the same token, any woman who ever danced with the neighborhood's Everette Wallace still recalls the pleasure of seeing him headed her way to ask for the next dance. "Old Faithful," as he was nicknamed at Gibbs High School for his generous, faithful ways to any worthy cause, was one of the smoothest dancers ever to grace the casino floor.

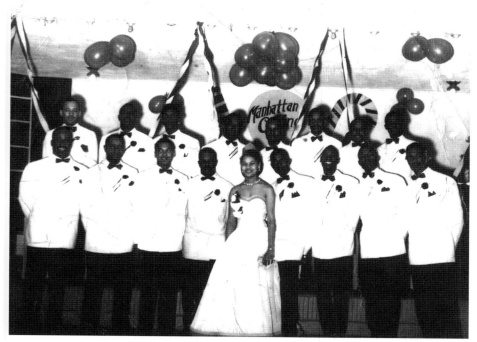

Club 16 holds its 1948 Christmas Dance at the Manhattan Casino. A few dancers are unidentified or partially identified. *Front row, from left:* Lotus Berry, Edward Franklin Davis, Ernest Ponder, James J. Perkins, Rosalie Peck, Major Kelly, unidentified, Harold Davis and Augustus Stamper. *Back row, from left:* Miller Johnson, a club member recalled only as "Smiley," unidentified, Robert Pettigrew, Albert Brooks, Everette Wallace, unidentified and Claude Barnes. *From the private collection of Rosalie Peck.*

More than that, to dance with Wallace was to glide with him up one side of the dance hall and down the other, affording the opportunity of seeing and being seen by friend and foe alike, in one's new finery, moving with the ease, grace and poise of Fred Astaire and Ginger Rogers. From the most skillful dancer to the mediocre, every woman looked good in his arms and looked forward to her turn. And the beauty of it all was that his lovely wife, Ella Mae, never seemed to mind.

Other smoothies on the dance floor included Sonny Mart Gibson, James Walker, Althea "Tubby" Jones, John L. Reese and a brother and sister team, Johnnie Mae and "Junior" Sturgis. But talk to any woman who enjoyed good times at the Manhattan Casino in its heyday, and when it comes to dancers remembered, a smile and the name Everette Wallace will pop up every time. The exception would be Betty Fuller, a dancer's dancer, whose favorite partner

was Raymond Wimbish, the brother of Dr. Ralph Wimbish. They made a whirling, light-on-their-feet couple whose intricate steps and style never failed to draw a circle of admirers.

As a Davis Elementary School student, Fuller was selected by her teacher Amanda Howard to participate in a play entitled *Tutti Fruitti*, and did a solo that earned her the reputation as a true dancer. As a young adult, she became known as a number-one dancer at the Manhattan, with Wimbish as her all-time favorite partner. Of all the orchestras and bands that graced the pulsating hall, Betty and Raymond especially loved dancing to the music of Buddy Johnson and his electrifying rhythm.

Former resident Jacob Simmons remembered that when it came to dancing, Tommy Wright and "Sonny Boy" Anderson were two of the best jitterbugs ever to climb the narrow stairs to the polished dance floor. "Joe Wyman was a great jitterbugger, but he was second to Tommy and Sonny Boy," Simmons said.

Excitement throughout the community would peak as nationally renowned bands' big tour buses arrived and parked in front of the Manhattan. Word spread fast. The band was in town—maybe it was Buddy Johnson and his orchestra, in the flesh. Former Gibbs High School student Frank Royal, who played trumpet in the band with extraordinary skill, was home once more. His mother would sit

Louis "Satchmo" Armstrong takes a break from a Manhattan Casino gig in the company of two fans, Josephine Smith (left) and Esther Peck Thomas. *Courtesy John L. Smith Jr.*

that night in the usual chair of honor on stage, proudly yet modestly watching hometown friends marvel as her son hit the high notes. After the dance, Buddy Johnson and his sister Ella would be made comfortable as guests at the home of their friends R.C. and Bernice Barnes. The rest of the band would check into the Robert James Hotel across the city in Methodist Town for steak dinners and a good night's sleep.

Between the first note and the last dance, Arthur Prysock would smile as women swooned at the incomparable sound of his mellow voice, not to mention his incredible good looks. "She wore blue velvet," he crooned, while, on one occasion, Esther Thomas, a beautiful woman with flirty intentions, called out teasingly, "No! Black!" calling attention to her lovely, black velvet dress. Esther's flirting did not go unnoticed. She smiled back toward the bandstand, pleased.

Integration of sorts came to the Manhattan Casino each time Louis "Satchmo" Armstrong played the hall. White music lovers stood shoulder to shoulder with the regular crowd in front of the bandstand, applauding and rocking to the music. For several hours, 22nd Street South at night was not off limits to whites. The Manhattan Casino was no longer taboo, color no longer an issue. Music was the equalizer. Or rather, the immortal man with the horn and gravelly voice was

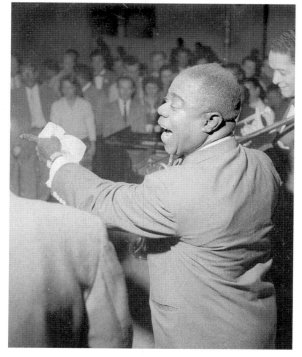

Louis Armstrong attracted a rare white crowd when he played at the Manhattan Casino, as in this 1957 photo. The audience included both whites and blacks, although the mix is not apparent in this image. People who attended recall that everyone got along because Satchmo's music was an equalizer. *Courtesy St. Petersburg Times.*

the equalizer and the charm that brought people together. Humanity prevailed. Mutual courtesy became the rule. And at least for a little while, in a Southern city of two worlds, one black the other white, all was well. Then, like Cinderella at the ball, the clock struck midnight. The music stopped. Apartheid returned. But to this day, there are white men who, at the mention of the latter-day revival of 22nd Street, will say casually, with an inflection of prideful satisfaction, "I've been to the Manhattan Casino. Been there several times. Saw Louis Armstrong there. Every time he came to town."

John Breen was a delivery driver for a pharmacy in March 1957 when he learned Armstrong was in town. He bought tickets on sale at Mercy Hospital, and he and his wife, Marion, attended. So did a number of other white couples. "There was absolutely no problem. All of us were talking back and forth. It was fine," said Breen.

When the big names weren't booked, local musicians kept the music going. Alvin Downing and Al Williams were among the top hometown musicians. George Cooper organized the first big, African American band in St. Petersburg. The sixteen-piece orchestra performed as a Manhattan house band from 1936 until the 1950s. Admission to the regular Friday dances ranged from fifty to seventy-five cents.

Other local artists included the Chocolate Drops: the brothers Jerome, Jimmie and Carl Brown, and lifelong friends Joe Clark and Horace Cooper, later joined by Robert Harris. And there were vocalists extraordinaire William Dandy, Louise Lavine, Elsie Dorn McGarrah and Willis Wilson.

Music has always been the heart and soul for relief and pleasure in the black communities of America. In St. Petersburg, the Manhattan is remembered with passion for its role in uplifting the spirit of black people at a time when the idea of liberty and justice for all was still a dream. And for decades, it was the incubator for talents that otherwise might never have seen the light of day.

Many young, black musicians developed their musical talent under the tutelage of Downing, whose Gibbs High Revelers afforded opportunities for both boys and girls, some who went on to become world-class musicians. Later came Reynold Davis, another Gibbs High School band director who made a lasting impact on students and who also arranged music for the Manzy Harris orchestra. Samuel Robinson made his mark, bringing out the best in his students. A local jazz festival is named in his honor. Grant McCray, Warren McCray, Leroy Barton, Oscar Dennard and Evans Haile are remembered among the talented musicians who benefited by early high school band and orchestral training.

Several became world travelers as professional musicians, including brothers Steve and Buster Cooper, who played with Count Basie and Duke Ellington,

respectively. They were cousins to George Cooper. Buster Cooper started his musical career at age fourteen, playing the drums. He later switched to trombone because, he said, when he played drums, "by the time I packed everything up, the girls would be gone."

Buster, who delivered the black-oriented *Pittsburgh Courier* on a neighborhood paper route, grew up on 9th Avenue South and 25th Street. His music soon took him a long way from St. Petersburg. After a stint in Omaha, Nebraska, and a short return to St. Petersburg, Cooper headed for New York City, where he played in the Apollo Theater's house band. He played with Lionel Hampton when the orchestra performed at the inaugurations of presidents Harry S. Truman and Dwight D. Eisenhower. In the 1960s, he hooked up with Ellington and lived for a time in Paris.

Other stellar musicians who got their start under Downing at Gibbs were Frank Royal, who played with Buddy Johnson; Syl Austin; Leonard Graham (whose stage name became Andress Suliman); and Chet Washington, who played with Earth, Wind and Fire.

Downing's passion for music resulted in the founding of the Alvin Downing Jazz Society, which continues as a legacy to his love of the music. And the state-of-the-art theater at Perkins Elementary School on 22nd Street is named for Downing.

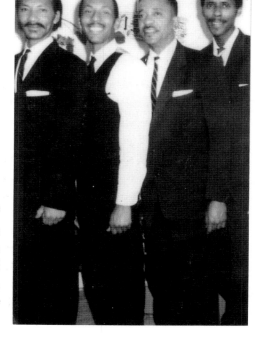

The Chocolate Drops grew up in the 22nd Street neighborhood and sang at the Manhattan Casino, often backing up the Manzy Harris Orchestra. *From left:* (all brothers) Carl Brown, Joseph N. Brown, Jerry Brown and Jimmie Brown. *Courtesy Nadine Seay.*

Almost without exception the fun-filled evenings at the "Home of Happy Feet" are recalled with amusement and cherished memories. But life at the Manhattan didn't always proceed without disagreements. According to most people, any disturbances at the dance hall were minimal and short-lived. Henry Woodard recalls skirmishes and near fist fights occasionally occurring between high school boys or girls. But those childish disturbances were quickly quelled through intervention of other youngsters. Adult temper flare-ups, Woodard said, were cut short by friends and other peers. In later years, he recalls, proper decorum was guaranteed by the pride-felt presence and intervention of black police officers of St. Petersburg's finest: Titus Robinson, Willie Seay, Louis Burrows and Sam Jones, the first African Americans to be hired by the city as policemen.

During those long-ago days when such musicians as Tiny Bradshaw, Andy Kirk and Noble Sissle thrilled the crowds, parents didn't have to think twice to answer such questions as: "Do you know where your child is tonight?" When a band was swinging at the Manhattan, parents knew where their children were. They also knew that when the music stopped the dance was over, and they knew how soon their child should be getting home.

During the fun-filled days of faddish zoot suits, long gold chains, broad-brimmed hats and fancy shoes, among the unforgettable gentlemen were the dapper Cleveland Johnson, Raymond Wimbish and Theodore Gadson, known to all as "Hoddy Doddy." He always stole the show doing splits and twirls, to the delight of admiring fans. Geneva Scott and Lucille Beckom did the "Doe-loe," a graceful, hip-moving dance. Whether the dance of the moment was jitterbug, ballroom, waltz, two-step or the South American conga, sooner or later, everyone socialized while cooling off with a cold drink and a few moments near a fan or window before returning to the dance floor for more. No alcohol was allowed. And the last dance was always reserved for "that special one," or whenever possible, one's favorite dance partner.

After 22nd Street began to show the first, ugly signs of decline and decay, and with the Manhattan Casino eventually becoming a sad ghost of its glory days, newcomers to the city found it difficult to relate to old-timers' memories of better days there. But one young woman, after reading the poem, "Remembering 22nd Street: The Way We Were," said with the light of youthful enthusiasm in her eyes: "Oh, now I know what mama was talking about."

People who were there remember. Betty Fuller put it best in just five words when asked her thoughts about why memories of the Manhattan Casino have, after all these years, remained so fresh and cherished in the minds of people intimate with the old ballroom's heyday.

"It was all we had," Fuller said.

Street of Ambition

Businesses and Role Models

Chance has never yet satisfied the hope of a suffering people. Action, self-reliance, the vision of self, and the future have been the only means by which the oppressed have realized the light of their own freedom.

—Marcus Garvey

During the 1920s, 22nd Street still meant country. Old-timers still recall the crack of muleskinners' whips echoing through the woods. Newspaper accounts tell of police raiding moonshine stills in the Prohibition-era boondocks.

But industries existed nearby. They offered walking-distance jobs for new arrivals who were gradually building a new black population center farther from downtown and white neighborhoods. The newcomers needed life's basics, so stores sprouted along 22nd. The dynamic renewed its energy about fifteen years later when a public housing project called Jordan Park attracted hundreds. Residents and businesses were mutually dependent.

On 5th Avenue South and 22nd Street, Soft Water Laundry's whistle moaned at key hours several times a day, setting neighborhood rhythms for generations. During sixty-odd years in business, it employed thousands. "People folded, washed, whatever job they had to do. It was an institution," said Minson Rubin, who grew up during the 1950s and '60s in Jordan Park.

A few blocks north, Farmer Concrete Works made hex blocks for sidewalks in the elite North Shore neighborhood. Grounds Brothers Manufacturing worked

raw lumber into stairs, windows and doors for houses on Snell Isle, another swanky area. Georgia Engineering produced Augusta blocks used to pave streets, and the company installed sewers west of 16th Street.

Littrell Lumber Company supplied more material and jobs. Frederick H. Littrell, the company's founder, used a ploy during the Depression to suggest business was better than people thought. He had a mule and a wagon and lumber. Each day he would rearrange the pieces of wood in the wagon bed, put a sign on the wagon that said "Another delivery from Littrell Lumber," and drive through the neighborhoods, said his granddaughter, Virginia Littrell. Meanwhile, Atherton Oil Company sold kerosene to light lamps in the 22nd Street community, which in the 1920s had yet to receive electricity or running water.

"All these companies gave employment to many of our people, and it gave us a chance to build up," said Paul Barco, a longtime 22nd Street resident and businessman. As white-owned industries helped boost the cash flow around the 22nd Street neighborhood, black-owned or operated businesses provided much of the neighborhood's backbone. They provided more than places to shop, be entertained and find professional services. The entrepreneurs, both male and female, gave young people models to emulate.

A child of the community during the 1930s, co-author Rosalie Peck liked to sleep late, even on school mornings. Jordan Elementary principal Marie Pierce rang a brass hand bell to start the day. Its clatter often brought young Rosalie sprinting down a dirt road between her house and the brick school a couple of blocks away. Mrs. Pierce kept ringing until all her students skipped inside. Teachers cared. They drilled the basics year after year, and they hammered home the names of black people to emulate. "Do you know Dr. Ponder? Well, that's what you can do if you study."

Dr. James Maxie Ponder and his wife, Phannye Ayer Ponder, came to St. Petersburg from Ocala, Florida, in 1924. The World War I veteran served as Mercy Hospital staff physician for many years and was appointed city physician for St. Petersburg's black population in 1926. Mrs. Ponder, a noted civic leader and educator, taught social studies at Gibbs High School. She was a friend and political associate of Ms. Mary McLeod Bethune, founder of Bethune-Cookman College in Daytona Beach. Mrs. Ponder is also remembered as the organizer and founder of the City Federation of Colored Women's Clubs. She founded the St. Petersburg Metropolitan Council, an affiliate of the National Council of Negro Women. The Council House, which she spearheaded on 19th Street South and 9th Avenue, has been designated a historic site. Mrs. Ponder was Dr. Orion Ayer's aunt.

Twenty-Second Street had its own medical row. Six black doctors had offices there: Fred W. Alsup, Orion Ayer Sr., Johnny Clark, Benjamin L. Jones,

Dr. Robert Swain, a dentist and civil rights activist who had an office on 22nd Street, poses with assistant Janie Butler in 1955. *Courtesy* St. Petersburg Times.

Robert J. Swain and Ralph M. Wimbish. A few blocks away were Gilbert Leggett Jr., Eugene Rose and Harry Taliaferro. Ponder's office stood on 5th Avenue South, known as "Sugar Hill," where many affluent and influential African Americans lived.

"All of these physicians provided a tremendous impact in enhancing and expanding a well-developed black middle class in St. Petersburg," wrote Mary Dolores Gordon in a 1994 letter to the St. Petersburg city government, urging it to grant Mercy Hospital historic site status. A registered nurse on Mercy's staff for fifteen years, Gordon said the medical men's presence "added a new dimension to black societal lifestyle and their families became a catalyst for change and improvements in enhancing the educational prospects for black children and in the area of civil rights."

Alsup, a physician and civil rights leader, came to St. Petersburg in 1950. He opened a practice at 623 22nd Street South, three blocks from home. In those days, when housing options were restricted, it was typical for professionals such as doctors or lawyers to live close to the wage earners they served.

Among Alsup's close neighbors were construction worker Joe Lindsey and his wife, Ruby, a maid at a downtown hotel. Alsup delivered eight of the Lindseys' nine children. He was a staff physician at Mercy Hospital, and in 1961, he

admitted the first black patient, Mrs. Altamease Chapman, to Mound Park Hospital, now called Bayfront Medical Center.

As a dedicated community activist, Alsup fought segregation and prejudice on many levels. *Alsup vs. The City of St. Petersburg*, a four-year battle, opened city-owned beaches to blacks for the first time. *Wimbish and Alsup et al vs. Pinellas County Commissioners and Airco Golf Corporation* opened county-owned golf courses to blacks. Alsup also marched in the streets to integrate businesses in downtown St. Petersburg. During student demonstrations in the 1960s, he provided bail for black students who otherwise would have served time in jail.

The professionals along or near 22ⁿᵈ inspired the neighborhood's youngsters. "They were role models for me," said Ernest Fillyau, who lived west of 22ⁿᵈ on 8ᵗʰ Avenue South. As an adult, he lived for a time in Jordan Park, the public housing project virtually next door to the heart of 22ⁿᵈ. "I wanted to be a businessman. I wanted to own a business. Those things motivated me to go to school even though I was poor," Fillyau said.

As a youth, Fillyau milked a cow owned by a teacher, Mrs. Ethel Bennett. His pay was a share of the milk. He picked up empty bottles, turning them in for change. He and his father raised chickens and, for the dog track's racing greyhounds, rabbits. Hunters paid Fillyau to pluck the quail they'd shot.

Ophelia Wilson, shown holding her daughter Edna Jeanette in a 1930s photo, was a successful female entrepreneur on 22ⁿᵈ Street. She owns the building that now houses the 22ⁿᵈ Street Redevelopment Corporation. *Courtesy Ophelia Wilson.*

William H. "Buddy" West became a 22nd Street businessman during the 1930s. He was a tailor and a barber while also promoting some of the community's musical shows and big-name entertainment. He was still working on the street in 2005, the oldest of the strip's pioneer businessmen still there. *Courtesy Joseph Horning.*

Ophelia Wilson, who came to St. Petersburg in 1935 from Lax, Georgia, operated a beauty shop until 1942 at 1117½ 22nd Street. She lived just a few blocks away at 19th Street and 11th Avenue. She was one of the first tenants of Jordan Park until purchasing a house next to the beauty shop. She eventually sold the house to First Mt. Zion Church.

In 1954, Ophelia married Samuel L. Wilson. The couple lived at 1025 22nd Street, eventually moving the house to the rear of the property and converting it into Pamela's Laundromat, named after her grandchild, Pamela Mills. It is believed to be the first such black-operated business in St. Petersburg. It was open from the late 1960s to 1989, when the property was rented to educator J.D. Brown, who for several years operated Brown's Fuel Oil Co. there. Later, the property housed Adams Beauty Shop and, at the time of this writing, is home to the 22nd Street South Redevelopment Corporation, the organization that spearheaded the successful effort to win state Main Street designation for the old business district.

William H. "Buddy" West opened his first shop on the 600 block in 1934. He was a tailor and a barber. His shop became a hobnobbing spot. So did Joe

Yates's shop down the street a few years later. In evenings, crowds would gather to hear radio broadcasts of Joe Louis's heavyweight championship fights, and later those of Ezzard Charles, Sugar Ray Robinson and Jersey Joe Walcott. When Jackie Robinson broke Major League Baseball's color barrier in 1947, residents clustered near radios to follow his progress. Every hit and stolen base were noted as news, and passed up and down 22nd Street.

As on African American streets everywhere, 22nd Street became a place to pass the time with friends. Rosalie Peck and her mother Octavia Peck enjoyed afternoon walks when Geech's barbecue stand began wafting its spicy vapors through the neighborhood. The Pecks would head north from their house on 10th Avenue to the post office substation under the Manhattan Casino, hoping a letter might wait in Box 306. On the way, they'd buy apples at Sidney Harden's grocery store on 22nd and 9th Avenue. Friends would greet them on the street. There was always a lot of talk, Southern-hospitality style. People would stop and chat.

Harden's enjoyed a reputation for selling tasty fruit—the best apples in town, pears, red and white grapes. It was also a cultural market. There were chitterlings and, in time for weekend dinners, whole hogs' heads glared through the glass of the meat counter, which also contained opossums, raccoons and rabbits. "Sunday they'd be all gone," said Minson Rubin. Youngsters who wanted to

Harden's, a neighborhood grocery store, advertised on its outside wall. It was open from the 1940s until about 1990, and this fading sign, still present in 2001, was painted over in January 2002. *Courtesy* St. Petersburg Times.

R.C. Barnes sits behind the wheel of his cab in the late 1950s. Standing is Shellie Christian Jr. R.C. and Bernice Barnes were hosts to Buddy and Ella Johnson when the Johnson orchestra came to town. *From the private collection of Rosalie Peck.*

feel grown up went to Harden's to buy chocolate chip cookies, two for a penny. "Then you'd walk back home thinking you were somebody," said Rubin, who grew up in Jordan Park.

Before Harden opened his grocery store, he owned a cab about 1938 or 1939, recalled Jacob Simmons. It was a Chrysler with a slogan on the side that said: "If you want to go to town and don't want to be late, catch Sidney Harden and his Chrysler Eight." R.C. Barnes also operated a taxi.

A block south of Harden's, S&S Market hired youngsters on bicycles to deliver door to door. Years after he worked at the store during the 1950s, Clarence Jackson was recalled as one of the best. Jackson's friends called him Pop because he was the oldest boy in his family. He was a slender youngster, quick on the bike. "It was a pretty good job. I made about $10 a week," said Jackson. Meyer Miller, a Jewish man, owned the store at 963 22nd Street South.

Jewish merchants were among the earliest entrepreneurs on the street, starting in the 1920s. Religious intolerance made it difficult for them to gain a foothold on downtown Central Avenue, dominated by white, Protestant business interests. Adding to the hostile environment was the Ku Klux Klan, which in the 1920s was at the height of its revival.

Businessman William Strong owned the Greenback Dollar and is credited with being the first person of color in St. Petersburg to buy a Cadillac from a downtown dealer. *Courtesy Gussie Wilkerson.*

St. Petersburg resident Bunnie Katz recalls her father, David Rothblatt, as one of the Jewish entrepreneurs. He opened a grocery on 22nd Street during the 1920s. "That's where a lot of people got started," said Mrs. Katz.

Despite segregation's attitudes and barriers, the white-owned industries helped 22nd Street grow, and despite city fathers' official attempts to keep black and white businesses apart, white people helped develop 22nd Street between 5th and 15th Avenues South. Some owned property or businesses, such as Horace Williams Jr. and Bill Boardman, who opened the Royal Theater. Others sometimes were silent partners for blacks who fronted enterprises.

Charlie Williams, the businessman and behind-the-scenes political fixer who also operated in the shadowy world of illegal gambling, was a friend of Manhattan Casino promoter George Grogan. According to a city government report detailing the Manhattan Casino's history, Grogan and Williams were business partners. Williams had connections with the white establishment downtown, and was able to tap money to help pay big-name musicians coming to the Manhattan.

Twenty-Second offered plenty of bars and nightspots besides the Manhattan. Among the most successful was the Greenback Dollar. William Strong operated it at 722 22nd Street, next to Joe "Bonimo" Rodriquez's El

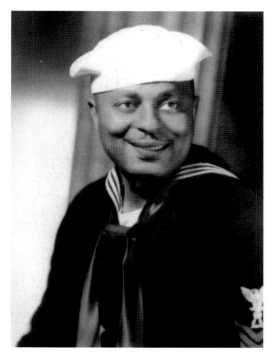

Columbus Wilkerson, who had a pool hall on the bottom floor of the Manhattan, also owned the S&W Restaurant and helped promoter George Grogan book bands into the Casino. *Courtesy Gussie Wilkerson.*

Rancho. The El Rancho opened in 1951 as a restaurant specializing in deviled crabs. It's also remembered for introducing shrimp-and-french-fry meals to the neighborhood.

Strong is credited with being the first black in St. Petersburg to buy a Cadillac. During the mid-1950s, he paid cash to downtown's Dew Cadillac for a gray Coup de Ville. He bought it for his daughter, Gussie Wilkerson, an educator who had returned from graduate studies at New York University.

"It was the talk of the town," Wilkerson recalled years later. Her husband, Columbus Wilkerson, was a multi-talented entrepreneur. He operated a pool hall in the Manhattan building, opened the S&W Restaurant and helped George Grogan promote the dances at the Manhattan.

Years after the old 22nd Street vanished, the people who had lived, shopped and played there remember fondly the places they patronized on the street and in other African American neighborhoods.

"It's the first impression that counts," was the satisfaction-guaranteed slogan gracing Maggie's Beauty Box at 961 22nd Street. Old-timers still recall the friendly atmosphere at Blankumsee's Groceries, three blocks west of 22nd at 821 25th Street. George Bennett's grocery store near the corner of 9th Avenue

Charlotte McCoy, one of 22nd Street's successful female entrepreneurs, bought Doctors Pharmacy in the 1960s. She is standing outside the business in the 1400 block of 22nd during the early 1970s. *From the private collection of Rosalie Peck.*

Elijah Moore, the peanut vendor known as 'I got 'em,' sold produce on 22nd Street and all over town for more than fifty years. He was a fixture in the annual Festival of States parades. *Courtesy* St. Petersburg Times.

Doretha Cooper Bacon, shown helping with a meal, became another successful entrepreneur, starting a catering business and the Doe-Al restaurants specializing in Southern cooking. She is the sister of musicians Buster Cooper and the late Steve Cooper. The siblings grew up in the 22nd Street community. *Courtesy Buster Cooper.*

South and 25th Street was, for a time, also the convenient location of Ola Hall's Beauty Box. They remember pharmacist Charlotte McCoy, who bought Doctors Pharmacy in the 1960s and top-hatted Elijah Moore selling peanuts and produce from a pushcart for more than fifty years, on 22nd Street and, it seemed, everywhere else in town. Poncy Rimes ran a restaurant, worked as a mechanic and dabbled in a half-dozen other businesses, and was often seen in a pair of greasy, work overalls. Doretha Cooper Bacon became a success with her Southern-cooking Doe-Al restaurants across the city, and her catering service. Mr. and Mrs. Willie Gregory were gracious hosts at Bill's Café, 299 Jackson Street North in Methodist Town.

Miss Minnie's Little General Store stood on the corner of 10th Avenue and 25th Street, across from the Jordan Park housing complex. Near 2nd Avenue South and 9th Street, across from Webb's City, Major Kelly the tailor designed zoot suits and peg-bottom trousers for young men and perfectly fitted slacks for stylish young women. Walker's Grocery Store at 1200 5th Avenue South, a family business owned and operated by the parents of musician and smooth dancer James Walker, one of Gibbs High School's most popular students, provided choice meats and groceries to a large segment of the community, including the affluent black families of 5th Avenue South, the Sugar Hill

neighborhood. Well-dressed women showed up for church every Sunday morning wearing lovely hats from Ann Stockton's popular Ann's Hat Shop at 990 2nd Avenue South near the Harlem Theater; well-groomed men sported polished shoes after routine stops at Chism's Shoe Shine Parlor at 1400 12th Street South. At 6 Magnolia Arcade, in the heart of segregated downtown St. Petersburg, William (Bill) Williams provided shoe repairs, polish and shines to patrons from all neighborhoods and all walks of life and Cecil Odom was always busy at Cecil's Shoe Shine Parlor at 1023 Burlington Avenue North, another Methodist Town location. Primus Butler and his son Primus Jr. cheerfully operated Butler's Shoe Hospital at 252 Jackson Street North and another on 22nd Street near the Manhattan, where Esther Peck Thomas, a teenager, worked after school and learned the trade of applying half-soles to well-used shoes. The third Butler repair shop was next to the bungalow-style family home on 7th Avenue and Union Street South, a stone's throw east of 22nd Street.

Black entrepreneurs during segregation were visible throughout the black community in the area of Gibbs High School: Joseph Albury Sr. practiced photography; Joseph Abram's father raised horses; Ernest Joseph's father had a vegetable farm and Willie Minton's father had a wood yard. Flagmon Welch operated another wood yard at 16th Street South and 5th Avenue.

Dr. Robert J. Swain in 1954 owned and operated the Robert James Hotel on Burlington Avenue North in Methodist Town; he also owned the Royal Hotel on 22nd Street next to the Royal Theater, the Clark Mortuary at 7th Avenue and 21st Street South and Doctors Pharmacy and Soda Fountain in the Wimbish building at 15th Avenue and 22nd Street across from Mercy Hospital. Co-author Rosalie Peck earned fifteen dollars a week as a sixteen-year-old working after school and weekends at Willie Curry's Photo Shop on 3rd Avenue South across from Davis Elementary School.

Success often blossomed despite socially hard times.

STREET OF CARE
Midwives and Mercy Hospital

We were all black and we were all poor and we were all right there in place. For us, the larger community did not exist.
—Barbara Jordan

During sweltering August afternoons, when the baby's time came, they took what they needed and trekked across sugar-sand paths, shimmering in the sun. On chilly January mornings, they wrapped in shawls and scarves and bent into the biting wind on their way to attend a birth. St. Petersburg's African American midwives were among the first to bring medical care to a growing community, first in tiny, wooden cottages near the railroad tracks, and later, as it began to blossom, to the neighborhood along 22nd Street South.

The Florida School of Traditional Midwifery says the state Department of Health noted four thousand midwives practicing in Florida in 1920, about the time 22nd Street began to be established. It is not certain how many practiced in St. Petersburg then, or in succeeding years—perhaps a dozen, perhaps one hundred. But memories of at least a few have survived.

Even after Mercy Hospital opened in 1923, mothers often chose to give birth at home. Midwives did a thriving business during the Mercy Hospital years. Among them was Georgia Wilson Brown of Dublin, Georgia, a widow who moved to St. Petersburg in 1922. At 2450 Irving Avenue South, her sons Joseph and Wales built her house, a wrap-around porch, and double-fireplace replica of her Georgia home. The community was undeveloped then, with

Georgia Wilson Brown was one of the community's pioneer midwives. She came to St. Petersburg in 1922 from Dublin, Georgia. *From the private collection of Rosalie Peck.*

Georgia Brown lived in this house her sons built at 2450 Irving Avenue South soon after she moved to St. Petersburg in 1922. The dwelling is a replica of the house she left in Dublin, Georgia, and is a typical example of early architecture in the 22nd Street community. *From the private collection of Rosalie Peck.*

few houses and a sea of palmettos and pines as far as the eye could see. The family had a relatively unobstructed view of distant neighbors and 22nd Street, three blocks away.

Other midwives came to St. Petersburg starting in the early 1900s, establishing themselves and becoming respected in the field. Among them was Mrs. Sally Givens, grandmother of notable teacher and dance instructor Pauline Givens Besselli. Givens was the mother of twin sons, Paul and Silas, and she established her large two-story home to accommodate "maternity services for home deliveries" on 7th Avenue South, one block west of 22nd Street close to the Manhattan Casino. She delivered Mattie Wright, a longtime activist in the black community.

Mrs. Mary E. Brown, the mother of educators L.D. and J.D. Brown and grandmother of realtor Lou Brown Jr., came to St. Petersburg in the early 1920s from Sumter, South Carolina. Her impressive residence was a large, white, two-story home on 12th Avenue South, where now stands the southwest portion of the Jordan Park public housing neighborhood. It was one block southwest of Jordan Elementary School, which opened in 1926.

Mrs. Phyllis Bradwell, affectionately known as "Sister Bradwell," lived near 31st Street and Fremont Terrace South, a few blocks northeast of Gibbs High School. Roxanna Donaldson, a member of the John Donaldson family, the first African American family to settle in St. Petersburg, delivered Goliath Davis, who became the city's first black police chief and in 2005 was the deputy mayor. Lyder Gass delivered Gwendolyn Reese, an African American cultural diversity consultant. Carrie Zanders oversaw the birth of longtime 22nd Street resident and businessman Paul Barco. A midwife recalled only as Mrs. Bennett delivered Dr. Robert J. Swain, a 22nd Street dentist and early civil rights activist; another known as Mother Welch delivered seven siblings in the Dennard family from 1928 until 1939. Other midwives from the era included Annie Lucas and a woman recalled as Mrs. Wideman.

When Mercy opened, general health and medical care for St. Petersburg's black citizens increased significantly but did not negate the popularity of home delivery nor diminish the practice of midwifery during the youthful and productive years of these pioneer women. Some of them continued their practices through the 1940s and into the '50s.

They traveled mostly by foot, using cars whenever possible, through narrow palmetto paths, dirt roads and ankle-deep, powdery sand beds to reach expectant mothers. Day or night, they covered every section of town where black families lived—in "quarters" and courts, scattered homes in the country, or "across town" in rooming houses and individual residences in increasingly populated neighborhoods.

These women were friends and neighbors as well as professional associates, who attended weekend workshops in Tampa and ultimately secured their certification and license to practice in Florida through board examinations taken in Jacksonville.

Besides providing services to women who did not want to go into a hospital to give birth, the midwives in general strengthened medical care for black residents, often bringing a spiritual aspect to their work.

The opening of Mercy continued in a formalized way the community's tradition of caring for its own.

During the Jim Crow era, many hospitals did not admit African American patients. Sometimes segregation laws forbade them doing so; sometimes hospitals simply refused to treat black people. As a result, black communities did what they so often had done before when shut out: they created their own amenities and made their own way. Such was the case with medical treatment. During the early to mid-twentieth century, more than five hundred black-only facilities were established across the nation in a focused effort to provide care for African Americans. Vanessa Northington Gamble has documented much of the work in several books, among them *Making a Place for Ourselves: The Black Hospital Movement, 1920–1944*.

St. Petersburg's segregation-era hospital for blacks was Mercy Hospital, situated at 1344 22nd Street South. It served its immediate community and other African American neighborhoods throughout St. Petersburg. Mound Park Hospital, later called Bayfront Medical Center, was the main white hospital.

Opened in 1923 on 22nd Street South, amid virtual country on the edge of town, Mercy, with its sixteen to twenty beds, often was poorly equipped and understaffed. Nonetheless, it boasted a corps of dedicated doctors and nurses. Long after the loosening of racial strictures in the 1960s, and after Mercy closed, the hospital remained a symbol of African American tenacity and pride in community. Additions to the hospital in 1948 and 1962 added to the pride hospital staff members felt.

"The staff had grave concerns for years regarding the inadequate facilities of the initial Mercy Hospital. Black physicians, nurses and staff considered the extension of the medical wings addition to Mercy as a historical milestone for Black medical care in the city," wrote Mary Dolores Gordon, one of the registered nurses at Mercy in 1941. "We were proud to encourage physicians, nurses and other medical help to move to practice in St. Petersburg because of the city's commitment to provide the new wings," wrote Gordon in a 1994 letter to a preservation board, urging the entire hospital, including additions, be named a historic landmark. Gordon worked fifteen years at Mercy.

In 2003, several workers helping build the new Johnnie Ruth Clarke Medical Center on the former Mercy site made a point of saying they had been born in the old hospital.

Actually, the venerable Mercy had a predecessor. It was established in 1913 in a five-room cottage at 4th Avenue South and 12th Street, in the heart of one of St. Petersburg's first black neighborhoods. The structure had been a white hospital called the Good Samaritan, built in 1910 at 6th Avenue South and 7th Street, a site where Augusta Memorial Hospital, Mound Park Hospital and, eventually, Bayfront Medical Center would be established. The Good Samaritan building was moved and dubbed "the colored annex."

It is doubtful that it offered much beyond a few beds and minimal care. But during National Hospital Day on May 13, 1922, the only published criticism from hospital board chairman A.R. Welsh, a white developer, was that better roads to the hospital were needed.

In 1923, the city decided to build a new black hospital on land community lore says originally was owned by African American pioneer Elder Jordan Sr. Dr. James Maxie Ponder, who moved to St. Petersburg from Ocala in 1924, spearheaded the drive that culminated in the construction of Mercy. He then served as a busy staff physician, handling the day-to-day, non-stop routines of a general practice, in addition to every medical crisis, including childbirth.

This section of Mercy Hospital was added in the 1960s. *Courtesy* St. Petersburg Times.

Peggy Duryea Day, a white woman who volunteered at the hospital as a teenager, recalled Ponder's hectic routine. One day while Day was working a shift, Ponder emerged from a delivery.

"Was it a boy or a girl?" someone asked.

"I don't know," Ponder replied. "I didn't have time to check!"

Ponder also plunged into emergency medical intervention and provided support for the midwives; he was instrumental in helping them achieve ongoing in-service training, including qualifying to take the state board examinations in Jacksonville.

When city fathers approved the Mercy Hospital project, it was not clear whether the approval was motivated by a desire to better serve a community's needs or simply to move an important service for African Americans to the town's outskirts. The non-controversial planning and the quickly completed project took place during the height of the city's 1920s boom, when African Americans who lived near downtown in long-established neighborhoods were being encouraged to move to more remote areas—not always gently, as the 1921 Dream Theater explosion showed.

Whatever the spur, the city gave builder Edgar Weeks the contract for the new hospital in July 1923. Weeks had submitted the low bid of $68,950. Henry Taylor, a St. Petersburg architect who designed such buildings as the Vinoy Hotel, drew the plans. Mercy opened later in the year.

From its beginnings and its separate and unequal burden, to its closure in 1966 as a slightly bigger facility, Mercy Hospital served a purpose, limitations notwithstanding. As older residents have expressed in regard to the importance of other community institutions during Jim Crow days: "It was all we had."

It was a time when the delivery of a telegram often meant an out-of-town relative had died. Neighbors guessed before a telegram's recipient knew the contents, and such deliveries fostered a dread not unlike seeing military personnel arriving at the door of the family of a man or woman in the service. A telegram's arrival meant bad news.

So it was when someone was admitted to the hospital. It was one thing when someone was sick at home. Concerned friends and neighbors rallied to the need for comfort, prayers and any other help they could offer a stricken family. Hope for recovery remained strong; optimism did not fade as long as the person was being cared for at home.

It was something else when a person went into the hospital. There was something about hospitalization that seemed to say: If a person is sick enough to be in the hospital, the person is sick enough to die. This fear persisted in spite of the fact that although people did die at Mercy Hospital, many others were

admitted, treated and released to continue their lives as before. Visiting relatives and friends in Mercy sometimes could ease the trepidation, but even that could produce anxiety, especially in younger people.

Douglas Seay recalled visiting, as a young boy, his older brother Willie in the hospital, dreading what seemed like unavoidable encounters with a strict, no-nonsense nurse who always questioned his reason for being there. Seay's wife Nadine laughs when she remembers the time when ambulance chasing was such fun. "Everybody did it," she said. Douglas Seay recalled standing outside the hospital peeking in windows, curious about what was going on inside.

Nadine Henderson Price, the daughter of Jesse and Helen Henderson, entrepreneurs and owners of Henderson's Sundries on the corner of 22nd Street and 9th Avenue, has different memories of Mercy. She said that when her mother was a patient there, she and her sister Katrina went at all hours, day and night, to visit, contrary to hospital rules and regulations. At some point, Mrs. Henderson was moved to a room next to the back door. Nadine and Katrina took that to mean they had carte blanche privilege to visit their mother at anytime, and they did so.

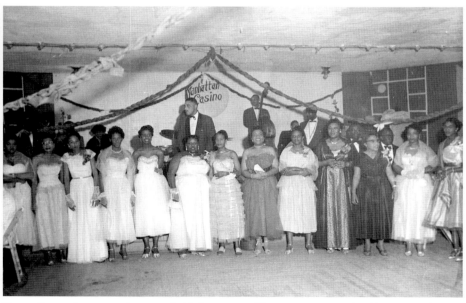

Mercy Hospital registered nurses held their 1958 Christmas party at the Manhattan Casino. Identified for this photo were, *second from left*, Marie Yopp, Pinellas County's first black public health nurse; *third from left*, Mamie Chapman; *fourth from left*, Zelma Reddick; *eighth from left*, Mary Brayboy Jones; *ninth from left*, Mattie Lou Coley; *tenth from left*, Annie Sue Brinson. In the center rear, under the sign, is Dr. Ralph Wimbish. *Courtesy* St. Petersburg Times.

Mary Brayboy Jones worked as a nurse at Mercy from about 1946 until the mid-1960s. Some of the other nurses she recalled included Sadie Henry, Hannah Singleton, Yvonne Taylor and Annie Sue Martin Brinson (whose mother Victoria Martin founded the St. Petersburg nursing home named for her). Marie Yopp, the county's public health nurse for African Americans, had her office on the Mercy grounds.

For some time, tuberculosis patients were housed in nearby buildings called pest houses, Jones recalled. And she remembered a well-dressed man who would walk around Mercy and pretend to act like the administrator or some other hospital big shot. In fact, he worked at Sears department store, and by serving at parties the Sears president threw, got to know doctors.

Jones had worked in Charity Hospital in New Orleans, and in a big hospital in Hawaii soon after the United States' entry into World War II in 1941. So Mercy seemed small by comparison. Jones said she took the night shift. Friday and Saturday nights could become tense and busy, she said, because of cuttings and shootings fueled by weekend drinking on the part of some. "I was a workhorse," Jones said. But the effort did not translate into equal wages. Jones said she earned ninety dollars less per month than what a white woman got doing the same nursing job at Mound Park.

Some white doctors helped the community. Dr. William Dicks, for example, maintained an office near the Manhattan Casino. So did Dr. William B. Lingo, who opened an office during the late 1920s. He had another at 11 4th Street North, in downtown's heart. Lingo came here from Atlanta in 1918, according to his 1966 newspaper obituary. In it, he was described as a philanthropist and educator who had both medical and law degrees and was a registered pharmacist. He was known for offering "paid" receipts at Christmas to people who couldn't pay their bills. Mary Brayboy Jones recalled that some white doctors came to Mercy because black people were not allowed to go to their offices. Mound Park, the white hospital, sent anesthesiologists.

A truck from Mound Park would bring instruments to be used in surgery at Mercy. At least one white doctor who insisted that instruments had to come over from Mound Park pushed for Mercy to get its own sterilizer. He feared the instruments could become unsterile on the way over.

Indeed, reviews from white doctors during the mid-1940s expressed the view that Mercy, despite a dedicated staff, remained far behind what a hospital should be. Dr. Gideon Timberlake, who served on the staffs of Mound Park and Mercy, told city council members it needed to investigate conditions at the black-only hospital. If they did, they would return "with a sense of pity and shame," Timberlake said.

His scathing remarks prompted the council to give Mercy higher priority on a list of upcoming projects. A 15,000-foot addition costing $212,742 to build was dedicated in 1948. It boosted Mercy's bed capacity to 55, compared to the 130-bed capacity at white Mound Park.

Still, Mercy remained cramped for an African American population that had surpassed 24,000 in 1960. That year, Dr. Edward Cole, then president of the Pinellas County Medical Society, and who would serve years later as St. Petersburg's mayor, pointed out in a newspaper article that the hospital had no pharmacy, no recovery room, no physical therapy, inadequate x-ray equipment and poor laboratories for diagnosis. In Cole's most damning indictment, he wrote that Mercy's infant mortality rate was ten times greater than what it was at Mound Park.

The criticism was an early volley in a new debate about Mercy's future. The city council in 1960 rejected a $1.7-million addition to Mercy. The same year, Mound Park administrators and physicians opposed integrating the white hospital. The city government contemplated a hundred-bed expansion at Mercy, but African American doctors, saying they were tired of the inherent lie behind the separate-but-equal façade, threatened to boycott the hospital if the city followed through on its proposal. When city leaders thought about building an annex for black patients at Mound Park, hundreds of white residents protested, agitating for a public referendum to decide the hospital integration issue. Black and white doctors, with the backing of white hospital administrators, ultimately decided to face down the impasse. They moved to integrate Mound Park.

"It was a racial thing and we got tired of it. It was time to stop having separate but not equal," Dr. Fred Alsup told the *St. Petersburg Times*. Mrs. Altamease Chapman, who had phlebitis in her left leg, was the first black patient admitted to Mound Park. It took place February 26, 1961, and according to news accounts, she was assigned to the last available room in the medical surgery section. Mrs. Chapman walked through the hospital's front door. Hospital administrator Don Rece escorted her. Police and a few press representatives were present, reporting that her admission went smoothly and that there were no incidents.

Chapman's admission represented a major step toward integration, which was coming to other public places in St. Petersburg: restaurants, movie theaters and shopping areas. It meant that some institutions in the black community were less needed—or not needed at all. Even though Mercy Hospital underwent an $865,000 expansion in 1962, adding three one-floor wings, increasing bed capacity to seventy-eight and adding obstetrics and surgery departments, two operating rooms, a recovery room and an enlarged pediatrics department, the facility remained understaffed. Critics again pointed out inadequacies in 1965

when a faulty incubator resulted in a baby being burned. The hospital closed on April 1, 1966.

For a while, no one knew what to do with it. The city tried to sell it but never attracted any seriously interested buyer willing to pay up to $600,000. The building served as a clinic, and in the 1970s a community group leased some of its space to provide food and shelter for poor people. A Head Start program operated there in 1971. Goodwill Industries leased space in 1973 to operate a drug and alcohol rehabilitation program. The property was renovated in 1984 with a state housing project in mind, but asbestos contamination forced closure in 1986. In the 1990s, a Clearwater company, Asimeno Corporation, bought it from the city, but never did anything with the building. In 1994, the city declared the remaining original building a historic site and in 1997 bought it back from Asimeno for $142,000.

Eventually, the city government arranged to lease the property to Community Health Centers, which operates the Johnnie Ruth Clarke Medical Center under a lease of one dollar per year. It does not have hospital beds, but provides a number of outpatient services for more than three hundred patients every day.

Named for the first African American woman from St. Petersburg to obtain a doctoral degree, the 26,000-square-foot center targets the health needs of poor and medically underserved neighborhoods. It has partnerships with Bayfront Medical Center, the University of Florida, Florida A&M University and St. Petersburg College.

The clinic began seeing patients of all races in February 2004.

STREET OF A NEW DAY
The Spirit Survives

We must transport our nightmares into dreams if we are to be a
successful people.

—John Hope Franklin

Reuben McCall liked the way home felt. And he had always wanted
to run a nightclub. "Ever since I was little, I wanted to own a Black
Cat," said McCall, referring to a 1940s-era club on 2nd Avenue South,
a short business strip in one of St. Petersburg's other African American
neighborhoods. "It was full of people. From the time I was fifteen years old,
I wanted me a Black Cat."

McCall opened the Champagne Lounge at 618 22nd Street South on
December 23, 1967. He didn't know it, but he had just missed the crest of 22nd
Street's wave. It peaked about 1962, then, before anyone realized it, began a
slow slide toward the rocks.

In its day, 22nd Street was a magnet. Segregation guaranteed it would be
a destination because the people who worked, shopped and played up and
down the street—including a solid middle class of professionals—had few
other choices. Now they do. The Pinellas Suncoast Transit Authority bus passes
through several times daily, bearing the same No. 7 as the old city coach that
served the neighborhood a generation ago. These days, the bus is almost empty.
It seldom stops to pick anyone up or let anyone off as it meanders toward Tyrone
Square Mall, a huge shopping center six miles northwest.

Segregation—in closing off opportunity elsewhere—created the conditions for 22nd Street's success: a place of, by and for black people; a place to call their own in a larger world that kept pushing them down and away. The very things that St. Petersburg's Midtown twenty-first-century planners want to create existed on the segregation-era's 22nd Street. Integration, for all its undeniable good, shifted the center of gravity away from places like 22nd toward white-majority shopping centers and entertainment venues. Without that critical mass, 22nd Street was bound to die. New doors opened in neighborhoods previously off limits. People moved out to Bartlett Park, Lakewood and Childs Park.

"It was like shooting into a covey of birds. Everywhere people could go they were gone," said Paul Barco, who owned a 22nd Street grocery store and has lived on the 900 block since the mid-1950s. Cut off for generations, people suddenly saw the possibility of freedom. Many left black neighborhoods simply because they could, not understanding they might also be leaving behind the sense of community that had sustained them. The new opportunities bled away residents who had been customers of 22nd Street businesses. Stores closed and jobs disappeared. Central Plaza and Tyrone Square Mall offered new places to shop.

At the end of an era, George Grogan surveys the Manhattan Casino building in 1974, about six years after the famed dance hall closed. The parked cars suggest a steady business was continuing in the first-floor package store, pool hall and other businesses. *Courtesy* St. Petersburg Times.

Bayfront Center provided a new waterfront venue for big-time entertainers, many of whom also began playing armories in Tampa and St. Petersburg. Big-name musicians who once electrified Manhattan Casino crowds regularly began playing big venues elsewhere. They no longer needed to rely on Chitlin' Circuit stops to make ends meet. The new era stymied George Grogan, the casino's master promoter. Suddenly, the old ballroom seemed dated. Its music stopped in 1968. Hyman and Abraham Fortunoff continued to run a bar and package store on the building's ground floor, but the days of the dances had ended.

The same year the ballroom closed, the city sanitation workers' strike stirred emotions and spawned riots. Some 22nd Street businesses burned, bringing St. Petersburg a taste of what larger cities endured during the turbulent 1960s, and further clouding life on the Deuces.

During the same decade, the drug culture emerged nationwide. Marijuana, cocaine and heroin showed up on 22nd Street, as elsewhere in St. Petersburg; drugs were reported in white neighborhoods like Shore Acres and Snell Isle, too. Police said dope dens festered near the old Manhattan. And gunfire rattled the neighborhood where the best music once echoed. People swept up live rounds and spent shells from the sidewalks. "It became the underbelly of the city," said realtor Lou Brown.

Patrolman C.T. Holland walks his 22nd Street beat in 1974. Shown is part of the 600 block, containing the Harlem Restaurant, a rooming house and Quick Cleaners. The Star service station's sign can be seen in the background. *Courtesy* St. Petersburg Times.

This 22nd Street scene in 1969 shows a section of the 700 block that would soon disappear in a few years because of interstate highway construction. Visible are Hale's Market, the Little Delicatessen, a nightclub and an unidentified laundry. Also visible is Gulf Coast Industrial Supply, whose address was on adjacent Fairfield Avenue South. *Courtesy St. Petersburg Times.*

Twenty-Second Street was already in decline when Interstate 275 pushed through its heart in the 1980s, uprooting houses and businesses. Relocating often meant better houses for people, but when the interstate crossed 22nd, it shoved out longtime businesses, made it harder to get around the neighborhood and threw a noisy divide across the area. "I think it was intended to destroy 22nd," said Moses Holmes, a retired National Education Association lobbyist. Many old-timers share that belief.

The Champagne Lounge stayed open until 1993, and closed just a few months after the state lifted the club's liquor license because of drug activity inside. The city bought the property in 2001 for $165,000. Unused for nine years, a scarred bar still sat in the old club as late as 2002. A coil of warping 45 rpm records sagged against a cardboard box. Amid the wreckage of tumbled stools, stacked cartons and haywire appliances, Reuben McCall reminisced.

"For many years, this was one of the nicest places you'd want to go in," McCall said. He hired local bands like the Brownstones to entertain. McCall wasn't suspected of selling the drugs police said were dealt in the club, and he wasn't charged with anything when the state beverage department lifted the

lounge's liquor license. It happened in a different era than the one McCall knew when he opened.

But times were changing. "Most of the people I was used to started disappearing," McCall said. "The younger ones had a different way of having fun."

As recently as 2004, a man was shot to death just off 22nd Street at about 7th Avenue South. But in general, the street is relatively quiet and violent crime is on the wane. Special events such as food festivals attract small, but appreciative crowds.

At some level, the segregation era's "lines" of old are recalled today. They don't speak of Jim Crow—at least overtly. But they can still suggest a lingering separation. Revised congressional maps drew new lines in 2002. They essentially segregated black neighborhoods from the rest of the city, linking them with a district in Tampa, and severing politically the largest black community in St. Petersburg.

For decades, the school district used lines to desegregate the schools. But in doing so, it often bused black children from schools closest to home to schools

Joe Lindsey walks his grandson Raleigh Lindsey to the school bus stop in this 2001 photograph. They are passing the old Harlem Restaurant, which already had been closed for some time. The Lindseys raised nine children in their home at 2117 6th Avenue South, and were among the last residents to leave their block when the city purchased it as part of an industrial park project. *Courtesy* St. Petersburg Times.

far away, where they were in the minority. City government also drew a line to define what it calls Midtown—2nd Avenue North to 30th Avenue South, between 34th Street and 4th Street. It includes the area that the city government helped segregate during the 1930s. The lines are supposed to draw attention to a community that needs economic help. The goal this time is to bring business in, not keep it out.

Some small-business life remains. Grady McCall—no relation to Reuben— starts cooking his "two-dollar holler" breakfast specials by 6:30 a.m. McCall's Family Restaurant is at 963 22nd Street South, the same address where the S&S Market thrived from the late 1940s until the late 1960s.

At lunch, the restaurant feeds retirees. Construction workers pop in, looking for home-style liver and onions instead of a sandwich off a cart. Up the street, faithful customers carry away steaming cartons of grouper, whiting and catfish from Lorene's Fish House.

In 2001 in the Boys and Girls Club, laughter echoed off the Quonset walls of what had been the Royal Theater. It became the street's happiest sound. In 2004, a renovation financed by the city and further boosted by businessman Bill Edwards turned the club into a virtual performing arts center with a recording studio and a stage. There is talk of showing movies again, as in the old days. City government, the St. Petersburg Housing Authority and federal officials worked together to open the Center for Achievement, an educational venue across the street from the Royal.

Memories of 22nd Street faded after integration. But lately, a culture of remembrance has begun to envelop the old thoroughfare, strongest among generations that came of age in the 1940s, '50s and '60s. "I think when people were living there, they didn't realize what it represented until it was gone. There's an old song that says you never miss your water until your well runs dry," said Holmes, the retired education lobbyist.

Nostalgia sometimes veils reality. No one longs for the lacerating Jim Crow system that shaped the community. But 22nd Street recalls values that transcended segregation's inequity. People will say with pride and a visible sense of loyalty that they grew up near the street.

St. Petersburg's downtown Central Avenue, blessed with banks, offices and a waterfront, required a generation's worth of perseverance before it came back from a mid-twentieth-century slump. Twenty-Second Street faces a comeback with far fewer advantages. But it does have pioneers who left influential memories and children who continue to make their marks.

Elder Jordan Sr., the pioneer developer, died in 1936. The school named after him is empty but is targeted for new use. A federal Hope VI development has modernized Jordan's namesake housing project, Jordan Park. Jordan donated

the land for both the school and the housing project. Jordan's grandson William Jordan went on to serve as program director of the New York chapter's National Council of Christians and Jews. Another grandson, Basha P. Jordan Jr., is a pastor in Baltimore.

David Rothblatt, the early Jewish grocer on 22nd Street, helped found St. Petersburg's first synagogue. Moses Holmes, who fed nickels to the Rockola at Henderson's Sundries, ran for the Pinellas County School Board in 2002 and continues to be a political activist. "I think one of the lessons of 22nd is, it teaches people that even though we're desegregated, you don't have to forget about what you had in your own neighborhood," Holmes said. He'd like to see African Americans spend more money in their own communities.

James B. Sanderlin, a young lawyer who had marched with the sanitation workers in 1968 and whose office was on 22nd Street, was elected in 1972 as the county's first black judge.

Ernest Fillyau, the poor boy who milked cows and raised rabbits, earned two degrees from Florida A&M and became a St. Petersburg City Council member. "If you're going to redevelop 22nd Street, develop it along the lines of family and mom-and-pop places," Fillyau said in 2002. "Let's get away from this plantation economy," he said, meaning a situation in which a company comes in with a few jobs but takes most of the money out of the community. Fillyau died in 2005.

Johnnie Swain, the generous butcher at S&S Market, worked there for thirty years and died in July 2000 at age eighty-three. People recall his generosity as they did that of the store's owner, Meyer Miller, who died at age eighty-seven in 1995. Clarence Jackson, who delivered the groceries, still rides a bicycle to his job at the *St. Petersburg Times*.

The memory of Elijah Moore, the "I got 'em" peanut vendor, was rekindled in the twenty-first century by Brady Johnson, who dresses in top hat and tails to sell produce at such downtown St. Petersburg venues as the Saturday Morning Market.

Minson Rubin retired after a thirty-year teaching career in Pinellas County. He devotes much of his time to preserving the heritage of Gibbs High School, 22nd Street and black neighborhoods. Plaques like those marking downtown's baseball history should be installed to commemorate historic spots in those neighborhoods, Rubin said.

William H. "Buddy" West, 22nd Street's oldest surviving businessman, at the time of this writing still goes most days to his barbershop where he gives a few haircuts, ten dollars a head.

Every morning, Paul Barco sweeps the sidewalk in front of his home on the 900 block. Ira Harding Wilson left his shotgun house on 22nd and moved to the

John Knox apartments. He died in 2003. "Twenty-second Street is deadsville now," Wilson used to say. He was always happy to spend a morning telling visitors how it used to be.

George Grogan, the legendary promoter, died in 1981. The Grogan Building, built in 1961 on 22nd Street's 600 block, was boarded and empty for several years before being demolished in 2004. Gospel promoter Goldie Thompson died in 1972, honored as an African American broadcasting pioneer.

Dr. Fred Alsup, a role model and civil rights pioneer, practiced until September 2001. He died at age eighty-eight in April 2002. Dr. James M. Ponder, who died in 1958 after crusading for better medical care for African Americans, became the first active black member of the Pinellas County Medical Society. Alsup is credited with being the first black doctor to receive full membership in the society and the first to join the staff of St. Anthony's Hospital. Dr. Ralph Wimbish, the Ambassadors Club founder and another civil rights activist, died in 1967. His widow, C. Bette Wimbish, two years later became the first person of color to be elected to the St. Petersburg City Council.

In the spring of 2005, the community's pioneer midwives were honored at a celebration held in the new Royal Theater. The event also paid tribute to current midwives who carry on a respected tradition and still practice in St. Petersburg.

Mrs. Lelia Bowers, a community matriarch, died in 2002 at age seventy-seven. Her family continued to serve fried chicken at the Sno-Peak until early 2005. Across the street, at this writing, the Manhattan Casino renovation project nears completion.

Behind the building, a monotonous river of sound whisks and rattles and drums as it arches over 22nd Street. It is the interstate traffic. In one sense, it is a reminder that the super highway helped end an era. But it suggests an urban energy that steadily recharges the old main street. Music again will spill from the Manhattan and happy feet will rock a new dance floor. New businesses will occupy the first floor, where others first thrived years ago.

Under the leadership of Mayor Rick Baker and Deputy Mayor Goliath Davis, the city government has fueled the street's revival. St. Petersburg College has established its Midtown Campus and the Johnnie Ruth Clarke Medical Center has become a busy successor to Mercy Hospital. The Royal Theater and its Boys and Girls Club draw daily crowds. McCall's and Lorene's, the two family restaurants, are well established, and in October 2005 a new supermarket opened—the neighborhood's first. A black history museum to honor a difficult era's pioneers is being established at the Jordan Park housing development. The 22nd Street South Redevelopment Corporation celebrated its eleventh anniversary in 2005, and its members' passions continue unabated. They

relentlessly pursue the street's rebirth as one of St. Petersburg's most important twenty-first-century dreams.

A powerful spirit holds 22^{nd} Street. You feel it at sultry midday in the clatter of workmen's hammers. You feel it at silent midnight at 22^{nd} and 9^{th} Avenue, the crossroads where it is so still you think you hear a blues note bending on a breeze and laughter riding a cloud. But the silence is about to change. A path cut from a forest continues to be a community's strength and spine. Its people stood against the world. They earned victories. Their resolute souls have moved on, but perhaps not so far away. You can feel them at work as a new dream rises. In this place called home, the spirit of 22^{nd} Street survives.

APPENDIX 1
"Remembering 22nd Street: The Way We Were"
A Poem by Rosalie Peck

Remembering 22nd Street: The Way We Were

*Great bands came to St. Petersburg then. Great music filled the hall.
Manhattan Casino...Home of Happy Feet...Oh, yes! We had a ball!
Count, Duke, Cab and Buddy...Erskine, Jimmy Lunceford, Louis
Armstrong and Fatha' Hines...BB King! Tiny Bradshaw...Fats Waller...
Clyde McPhatter...Ike and Tina Turner so fine...Otis Redding, Bill
Doggett, Lucky Millender...Cootie Williams...Ray Charles and Louis
Jordan, too...George Cooper, Manzy Harris, Alvin Downing, Al Williams
and the Versatiles...Dizzy Gillespie and the Drifters, who carried on 'til the
night was through.*

*Remember Arthur Prysock? Buddy Johnson's sister Ella? Ella Fitzgerald
and Sarah Vaughan? Remember William Dandy? Louise Levine? Elsie
McGarrah...and Frank Royal blowing his horn? Remember Joe Williams
doing his thing? If you were here, you do. If not, I'm here to tell you...Great
musicians thrilled us through and through. Musicians who couldn't be
beat...played for us when life was sweet...on 22nd Street.*

On 22nd Street we dressed up so fine as if not a care in the world. We strolled on Easter Sunday; Tuesday or Monday…We strolled just any ol' time. On 22nd Street where black businesses thrived. Where great leaders worked, played, lived and died…On the south side of town…way out in the "country" where plenty black pride was found.

Remember Geech's barbecue? Because there is no doubt; everybody who had a taste knows it made yo' brains fall out. And what about fine restaurants? Good home cooking served fresh and neat. Remember all the good places where we could go to eat? On 22nd Street?…The Harlem Restaurant, the Rendezvous…The Moonlight…Newkirk's…and Sno-Peak too. Romell's… The Spot…Yes, there were quite a few…All right there for the pleasure of me and you…Remember?…That was 22nd Street.

We had doctors…lawyers…tailors and barbers for you…We had the Royal Theater, the Royal Hotel, too! Mercy Hospital…pharmacies…grocery stores, too…Soda fountains, shoe repairs, and when life was through, there was a well-established funeral home to bury you. All of this flourished in a neighborhood where black families lived, worked, prayed and died teaching children to be good. Yes, the heart of this community was 22nd Street.

Life was the soul of this once-great street…like downtown Central Avenue, the place to meet and greet…But then one day the interstate came…Wiped out our history…changed everything…But remember the name 22nd Street, for like the Phoenix, one day it too may rise…It will never be the same, but before our very eyes, it may breathe life again. It may survive and surprise…Like an oak with a tap root it may refuse to die…22nd Street might still rise up to defy; and take its rightful place once more…Serving good people of St. Petersburg once more; under God's clear-blue spacious sky.

Appendix 2
A Historic Timeline of 22nd Street South

Here is a list of significant dates in 22nd Street South development, placed in the context of the national civil rights movement and race relations in St. Petersburg.

1888–89 African American workers who helped build the Orange Belt Railway begin to move to St. Petersburg, settling in an area known as Pepper Town, just east of what became 9th Street South, along what became 3rd and 4th Avenues.

1890–1900 Another African American community begins to form along 9th Street South, south of 1st Avenue South. In its early days, it was referred to as Cooper's Quarters, later becoming widely known as the Gas Plant area.

1894 The Bethel AME Church is founded at 912 3rd Avenue North. An African American community known as Methodist Town grows around it.

1910 St. Petersburg's population is 4,127, including 1,098 African American residents (about 27 percent), according to the federal census.

1913	The Democratic Party conducts a "whites-only" primary in a city election. Another "unofficial" one would be held in 1921, and a 1930s city charter had provision for a white primary.
1914	At 9th Street South and 2nd Avenue, townspeople and nightriders from the countryside lynch John Evans, an African American suspected of murdering white photographer Ed Sherman. The murdered white man's lawyer told his hometown Camden, New Jersey newspaper that city leaders met in secret to plan the lynching. Excited about growth possibilities, city fathers annex a long, narrow strip from 16th Street to Boca Ciega Bay, between 5th Avenue North and 7th Avenue South. It includes part of what would become the core of the 22nd Street South strip.
1920	St. Petersburg's population is 14,237, including 2,444 African Americans (about 17 percent), according to the federal census. Adding weight to segregation policies, St. Petersburg police say they will arrest white men found at night in black areas of town, whatever their age or social standing.
1923	Mercy Hospital opens on 22nd Street South to serve African Americans. At 515 22nd Street, Mayor Frank Fortune Pulver opens Chatauqua Laundry, forerunner of the Soft Water Laundry that will become a landmark business in the neighborhood.
1925	Elder Jordan Jr. builds what will become the Manhattan Casino on 22nd Street. About this time the Jordans also begin building housing in areas called "courts" just east of the Manhattan, and other housing in the 22nd Street area. Another huge city annexation, this one during the height of the real estate boom, balloons the south city limits to Pinellas Point, taking in 22nd Street south of 7th Avenue South.
1926	Jordan Elementary School, named for Elder Jordan Sr., opens on 9th Avenue South just west of 22nd Street.
1927	Gibbs High School opens near 9th Avenue South and Fargo Street, about a half-mile west of Jordan Elementary. According to community lore, black students walked from Davis Academy at 944 3rd Avenue South to stake claim to the new school, built for but never used by white elementary students. The school was named for Jonathan C. Gibbs, an African American who served as Florida's secretary of state and superintendent of public instruction during the Reconstruction era. The high school was in the middle of an undeveloped, wooded area jokingly referred to as "bear country."

APPENDIX 2

1930 St. Petersburg's population is 40,425, including 7,416 African Americans (about 18 percent), according to the federal census.

1931 A new city charter includes a clause banning white people from living or having a business in black neighborhoods, while forbidding black people from doing the same in white neighborhoods. It proved impractical to enforce.

1934 Fletcher Henderson becomes one of the first to bring a big band to play 22nd Street—but he doesn't play the Manhattan Casino. According to a newspaper story, promoter George Grogan booked Henderson's orchestra into a dance hall at 562 22nd Street South, about a block north of the Casino.

1936 The city council approves a resolution to make all African Americans live west of 17th Street and south of 6th Avenue South. The southern boundary generally is considered to be 15th Avenue South. Like the charter provision five years earlier that required business and residential segregation, the resolution couldn't be enforced to the letter.

1937 In full regalia, the Ku Klux Klan marches in July through black neighborhoods, including 22nd Street, to keep black voters away from a referendum.
 In October, an African American man shoots two white police officers in Campbell Park. Officer James Thornton dies on the scene and Officer William Newberry dies a day later. Police canvass black neighborhoods, and white mobs terrorize black residents. Police catch J.O. "Honeybaby" Moses and shoot him dead. Whites try to steal the body; some accounts say it was dragged down the street.

1939 Construction begins on Jordan Park, the city's first housing project, a block west of 22nd Street just south of 9th Avenue South. The first resident arrives on April 10, 1940.

1940 St. Petersburg's population is 60,812, including 11,982 African Americans (about 20 percent), according to the federal census.

1941 The second phase of Jordan Park is completed.

1944 The U.S. Supreme Court rules that white-only primary elections are unconstitutional.

1946	Reflecting the neighborhood's relative prosperity after the opening of Jordan Park and the end of World War II, a record-high fifty-eight businesses are open on 22nd Street, including two drugstores and several grocery stores and restaurants.
1948	Royal Theater opens at 1011 22nd Street South; Mercy Hospital is enlarged to fifty beds.
1950	St. Petersburg's population is 96,738, including 13,977 African Americans (about 14 percent), according to the federal census.
1952	Sixteenth Street School opens at 701 16th Street South to serve African Americans in grades kindergarten through eighth. It later is known as 16th Street Junior High, and is later rebuilt and renamed John Hopkins Middle School.
1954	The U.S. Supreme Court strikes down school desegregation as unconstitutional. In St. Petersburg, Dr. Robert J. Swain Jr. breaks the 15th Avenue South "red line," which defined where African Americans could live and open businesses. Swain, a dentist, crossed the line by opening an office at 1501 22nd Street South. At first the city refuses to issue building permits but relents when Swain threatens to sue.
1955	Rosa Parks refuses to give up her seat on a Montgomery, Alabama bus. Her act launches a black passenger bus boycott and leads to a Supreme Court ruling that laws requiring segregation on buses are unconstitutional. In St. Petersburg, six African Americans sue to end segregation at St. Petersburg's downtown swimming spots. In 1957, the Supreme Court rules in favor of Fred Alsup, Ralph Wimbish, Willet Williams, Naomi Williams, Chester James Jr. and Harold Davis. Alsup and Wimbish are physicians who have offices on 22nd Street; Harold Davis is a barber whose shop is also on the street.
1956	Robert Swain opens some apartments next to his office at 1501 22nd Street South. They are built to accommodate black Major League baseball players, barred by segregation policies from staying in white-operated hotels during spring training.
1957	Congress passes the Voting Rights Act.

1958 Despite the Supreme Court's decision the year before, the city refuses to integrate the downtown pool and beach, choosing to close them instead. The issue gradually dissolves as hoteliers and others dependent on the tourist industry worry that the closure will cost them money.

1958–66 Twenty-Second Street hits its heyday, peaking in 1960, when there are 111 businesses open. The list includes doctors, lawyers, restaurants, bookkeeping and accounting services, grocers, pharmacies, pool halls and taverns, variety stores, service stations, shoe and clothing stores, a photo studio, furniture stores and a post office substation.

1960 St. Petersburg's population is 181,298, including 24,080 African Americans (about 13 percent), according to the federal census.

 Lunch counter sit-ins at such Central Avenue stores as Woolworth's, Liggett's, Rexall, McCrory's and Kress lead to desegregation of most public dining places by 1961. Webb's City and Maas Brothers are among downtown department stores picketed.

 Fred Alsup pushes the "red line" on 22nd Street farther south, building an office and apartments at 1700 22nd.

1961 Freedom Riders begin traveling throughout the South, challenging segregated interstate bus service. In St. Petersburg, the Citizens Cooperative Committee, consisting of several African American civil rights leaders, including Fred Alsup; Ralph Wimbish and his wife, C. Bette Wimbish; and the Reverend Enoch Davis, took in the Freedom Riders during their visit in town.

 At Mound Park Hospital (now Bayfront Medical Center) Fred Alsup admits the first black patient, though the hospital still is largely segregated.

 Rosalie Peck and Frankie Howard are the first black students admitted to St. Petersburg Junior College, now St. Petersburg College.

1963 An estimated quarter-million civil rights supporters stage a march on Washington, D.C.; in St. Petersburg, picketers march in front of downtown movie theaters, pushing for integration.

 Three new one-floor wings are added to Mercy Hospital, bringing bed capacity to seventy-eight.

1964 — Congress enacts a sweeping Civil Rights Act banning segregation in hotels and restaurants and discrimination in employment; meanwhile, "Freedom Summer" sees massive African American voter registration efforts in Mississippi while extremists fight back with bombings and the murder of three rights workers.

In St. Petersburg, a night or two of disorder occurs between black and white patrons of the Barrel drive-in, a longtime white hangout on the edge of Methodist Town. Meanwhile, more African American patients are being admitted to Mound Park, where admission has become a matter of physician-patient choice.

1966 — Mercy Hospital and the Royal Theater close.

1967 — The NAACP opens an office at 1125 22nd Street South.

1968: — The city's sanitation workers strike from May through August for better pay, working conditions and benefits. The strike leads to unrest and, in August, four nights of rioting occur. Several businesses are burned, including some white-owned stores on 22nd Street.

Black and white leaders form the Community Alliance, a biracial organization to discuss sensitive issues.

The Manhattan Casino closes, although businesses below the second-floor ballroom remain open.

1969 — C. Bette Wimbish is the first African American elected to the City Council.

1970 — St. Petersburg's population is 216,232, including 31,911 African Americans (about 15 percent), according to the federal census.

1971 — Court-ordered busing desegregates Pinellas schools countywide.

1975 — Jordan Elementary School closes.

1978–81 — Families and businesses are relocated and Interstate 275 is built through the 22nd Street neighborhood, changing the street's dynamic.

1980 — St. Petersburg's population is 238,647, including 40,903 African Americans (about 17 percent), according to the federal census.

1989 — The old Soft Water Laundry, now called Prather's Linen and Uniform Service, is closed. Under various owners, the business operated in the neighborhood and employed many residents for sixty-six years.

Appendix 2

1990 St. Petersburg's population is 238,629, including 46,726 African Americans (about 20 percent), according to the federal census.

1993 The city earmarks $272,000 in federal grant money to encourage 22nd Street redevelopment from 5th to 22nd Avenues South.

1994 The city council designates the Manhattan Casino and Mercy Hospital sites as historic. It also approves a revitalization plan for the street, noting that vacant lots make up 25 percent of the street's land use.

1996 Two nights of racial disturbances occur in St. Petersburg, one in October and another in November, after police fatally shoot Tyron Lewis, an African American man. A liquor store at the intersection of 22nd Street and 18th Avenue South is burned down.

1997 The city buys the old Mercy Hospital site. The city council also declares Dr. Robert J. Swain's dental office and adjacent apartments on 22nd Street and 15th Avenue South to be historic sites.

1998 City officials say they plan to develop an industrial park on nineteen acres bordered by 22nd Street, 5th Avenue South and Interstate 275.

1999 Demolition begins at Jordan Park and many residents move elsewhere so work can start on the Hope VI program, which includes a rebuilt public housing project on the same site.

2000 St. Petersburg's population is 248,232, including 55,502 African Americans (about 22 percent), according to the federal census.
 Federal officials approve final plans for Hope VI.

2001 After intense effort by the 22nd Street Redevelopment Corporation and city government officials, 22nd Street wins Florida Main Street designation, a program to help revive aging business districts.

2002 The city buys the Manhattan Casino. An architect is hired to do a restoration plan. The last residents leave a 22nd Street neighborhood where work is starting on an industrial park's first stage.

2003 The Center for Achievement opens on 22nd Street and is designated the Midtown Campus of St. Petersburg College. It also offers other services, such as childcare, for people attending classes.

 The city council approves a deal that officials hope will put a supermarket on 22nd Street and 18th Avenue South, the first such market for the neighborhood.

2004 The Johnnie Ruth Clarke Medical Center opens on the historic Mercy Hospital site, offering a number of services to neighborhood residents, and a renovated Boys and Girls Club opens in the old Royal Theater building.

2005 Work proceeds on the new supermarket and on Manhattan Casino renovations.

Appendix 3
A List of Businesses from the 1940s

This is a list of African American business establishments in St. Petersburg during the 1940s. The inventory is not comprehensive and does not include the specialized practices of doctors, dentists, pharmacists, or health care, educational or legal professionals who in various ways had resounding impact on the economy and quality of life for St. Petersburg's black population.

This list does represent the variety and quantity of businesses—just a few of the total—that flourished during the 1940s on 22nd Street and in other African American neighborhoods in St. Petersburg. Where known, an owner, manager or employee is listed. In a few instances, addresses were not available.

Business	Address	Owner/Manager/Employee
Afro-American Life Insurance Co.	955 3rd Avenue South	H.B. Wynn Jr., William Butler
The Atlanta Life Insurance Co.	1006 2nd Avenue South	Mrs. P. Edge
Barco's Grocery	2034 7th Avenue South	Paul Barco
Better Way Cleaners	1411 2nd Avenue South	Henry Brown
Bill's Barber Shop	602 22nd Street South	Bill Jordan
Brown's Café	653 22nd Street South	
Bullard's Beauty Shop	2450 Irving Avenue South	Rosa Lee Bullard
Butler's Shoe Hospital	252 Jackson Street North	Primus Butler

St. Petersburg's Historic 22ND Street South

Business	Address	Owner/Manager/Employee
Carrie's Beauty Parlor	116 11th Street South	Carrie Jenkins
Central Life Insurance Co.	952 2nd Avenue South	Richard Smith, J.A. Whitehurst, F.A. Dunn
Citizens Lunch Stand	954 2nd Avenue South	Loomis Williams
Clark's Hotel	859 22nd Street South	Mary Roberts
Coats Lunch Room	936 2nd Avenue South	L.C. Coats
Cobb's Dress Shop	627 22nd Street South	Anita E. Cobb
Curry's Photo Shop		Willie Curry
Delux Cleaners	Burlington Avenue North	Gibson Forehand, C.J. Forehand
Dennis Grocery	2021 Melrose Avenue South	M.D. Dennis
Dixie Cut Rate Market	636 22nd Street South	
Dumas Restaurant	844 22nd Street South	Lila Dumas
Economy Barber Shop	660 22nd Street South	Willie Harrington
Eddie's Soda Shop	616 22nd Street South	
Elouise's Beauty Shop	1000 Burlington Avenue North	Elouise Johnson
Ethel's Beauty Shop	2139 9th Avenue South	Ethel Bludson
Everybody's Grocery Store	916 25th Street South	H.H. Church
Fannye's Beauty Shop		
Flower Brothers and Jones Furniture Store	740 22nd Street South	
Friendly Inn Barbecue Stand	457 16th Street South	
Fuller Beauty Salon	1576 3rd Avenue South	Selena Fuller
Great Manhattan Lounge	648 22nd Street South	C.J. Wilkerson
Green Palace Café	299 Jackson Street North	
Groover's Grocery Store	857 22nd Street South	Hadley Groover
Hall's Beauty Booth	25th Street South	Ola Hall
Harris's Market	600 22nd Street South	Joseph Harris
Henderson's Service Station	490 16th Street South	Jesse Henderson
Hicks Service Station	436 16th Street South	Peter Hicks
Hootsie's Shoe Shine	931 22nd Street South	Hugh Herring

Business	Address	Owner/Manager/Employee
Hub Service Station	436 16th Street South	C.D. McMurray
Jack's Shoe Shine Parlor	931 22nd Street South	
Jewell's Beauty Shop	801 22nd Street South	Jewell Ford
Johnson's Café	447 14th Street South	
Jones, Tonsorial Expert	944 2nd Avenue South	Elijah J. Jones
Jordon Park Drugs	863 22nd Street South	
Kleckley's Barber Shop	937 22nd Street South	Oscar Kleckley
Koppy Kat Beauty Salon		Delma Fountain, Mamie Boyd
La Vanity Beauty Shop	929 3rd Avenue South	Isabel Simmons, Thomas Simmons, Leola Harriel
Larry's Reliable Dry Cleaners	210 10th Street South	
Laura Lee's Kitchen	931 3rd Avenue South	
Lee's Beauty Shop	241 10th Street North	Bertha Lee
Lenox Grocery	908 22nd Street South	John Sheely
Lester's Dry Cleaning	941 22nd Street South	Marshall Lester
Lillian's Beauty Parlor	933 22nd Street South	
Lucille's Beauty Salon	1455 3rd Avenue South	
Mabel's Beauty Shop	720 21st Street South	
Maggie's Beauty Box	961 22nd Street South	Maggie Neal
McCloud's Barbecue Stand and Confectionary Shop	456 14th Street South	
McRae Funeral Home	1211 5th Avenue South	Monroe McRae
Moseley's Grocery	905 24th Street South	Julius Moseley
Moure's Barber Shop Delux	946 2nd Avenue South	Clarence E. Moure
Nesbit Quick Lunch	10th Street/2nd Avenue South	Herman Nesbit
Nixon's Grocery Store	2826 Fairfield Avenue South	Willie Nixon
Pressly's Grocery and Service Station	626 22nd Street South	
PX and Drugs	650 22nd Street South	Mr. and Mrs. C.J. Wilkerson
Rainey's Billiard Parlor	1054 Burlington Avenue North	C. Thompson

St. Petersburg's Historic 22nd Street South

Business	Address	Owner/Manager/Employee
Red Star Market	947 22nd Street South	
Reese Fish Market	630 22nd Street South	Charles Reese
Ross Radio Shop	1079 11th Street South	Ross McMullen
Ruby Lee's Beauty Shop	616 22nd Street South	Mrs. Ruby Lee Miller, Mrs. Lawinth Bellamy
S&S Market	857 22nd Street South	Johnnie Swain
Sam's Department Store	634 22nd Street South	
Smith's Grocery	1220 3rd Avenue South	J.B. Smith
Smitty's Tailor Shop	996 2nd Avenue South	
South Florida Furniture Co.	562 22nd Street South	
Southside Cab Company		George Hargray
Southside Cleaners	644 22nd Street South	M.C. Cooper
Sylver's Shoe Shop	952 22nd Street South	John Sylver
Sylvia Mickens Beauty Shop	2506 Harrington Avenue South	
Tenth Street Café	254 10th Street North	Ossie B. Moore
Tilmans Grocery Store	1215 18th Street South	
22nd Street Drug Co.	632 22nd Street South	
Two-Tone Barbeque Stand	1048 22nd Street South	
W.L. Kimsey & Son	640 22nd Street South	
Walker's Grocery Store	1200 5th Avenue South	
Wardell's 5-and-Dime	857 22nd Street South	
Williams Funeral Home	22nd Street/9th Avenue South	Nathanial Williams
Williams Grocery and Meats	905 22nd Street South	
Wylla Mae's Beauty Box	408 12th Street South	

Appendix 4
They Played the Manhattan Casino

Here is a partial list of musicians credited with playing on 22nd Street South, usually at the Manhattan Casino from the 1920s through the 1960s. Their names were collected from newspaper files, promoters' records and recollections from longtime residents.

A.C. Jones and the Atomic Aces A regional rhythm-and-blues band during the 1960s. A.C. Jones played a distinctive, decorative white guitar.

Louis Armstrong Daniel Louis Armstrong, a trumpet genius, is considered by many to be not only the most influential jazz musician of the twentieth century, but perhaps also the most influential American musician in any genre.

LaVerne Baker Baker is considered a pioneer in the fusion of rhythm and blues and rock n' roll during the 1950s.

Count Basie A pianist and later a bandleader, he became one of the more widely known figures in jazz and swing. He led a big band from 1935 until his 1984 death in Hollywood, Florida.

Bobby Blue Bland This blues singer, like his friend B.B. King, came from a Beale Street musical background. He is known for a string of big, 1960s rhythm-and-blues hits, including the standard, "Turn on Your Love Light."

Charles Brown A classical pianist with a chemistry degree, the mellow-voiced Brown had a string of rhythm-and-blues hits in the late 1940s and early '50s. His appeal leaped generations; he toured with Bonnie Raitt in the late 1980s and early '90s.

Professor Alex Bradford A composer, vocalist and pianist, Bradford is considered to be among the top gospel artists of the post–World War II era.

Tiny Bradshaw He was a college psychology major who chose music as a career, first making a name in the 1930s swing era and later moving to rhythm and blues. He led bands, sang, played the piano and drummed.

James Brown A huge figure in R&B and rock, the Godfather of Soul was an exciting, perpetual-motion screamer on stage. Using a start at the Manhattan Casino as an early springboard, Brown began his career with The Flames, which melded into James Brown and the Famous Flames. His monumental '60s hits included "Out of Sight," "Papa's Got a Brand New Bag" and "I Got You (I Feel Good)."

Cab Calloway A widely known entertainer and singer by the early 1930s, Calloway attended law school but quit for the love of show business. His first big hit was "Minnie the Moocher," a staple in his regular Cotton Club gig in Harlem. Calloway also appeared in several movies.

Ray Charles The author of a song called "St. Pete Florida Blues," Charles first studied music at the St. Augustine School for the Deaf and Blind. Glaucoma took his sight at age six. His highly recognizable vocal style is a mix of rock, rhythm and blues, country and gospel. "What'd I Say" was his first Top-10 hit.

Savannah Churchill A Creole born in Louisiana and raised in Brooklyn, the sweet-voiced singer was considered a star in the late 1940s when she toured the nation. She had several hit records and appeared in a few movies.

Fess Clark A barber in St. Petersburg during the day, he played the piano at night at various venues, including the midnight show at the old La Plaza Theater downtown. "St. Louis Blues" was his favorite song.

APPENDIX 4

The Reverend James Cleveland An influential gospel composer and director, he recorded a version of Ray Charles's "Hallelujah I Love Her So" that fused spiritual music with rhythm and blues.

Dorothy Love Coates A passionate gospel singer whose songs often carried more than a hint of blues, Coates also made a point to publicly oppose segregation during the volatile 1950s and early '60s.

Sam Cooke One of eight sons of a preacher, Cooke began as a gospel singer. "Twisting the Night Away" was one of his hits. A charter member of the Rock and Roll Hall of Fame, he came to the Manhattan with a gospel group, the Soul Stirrers.

Buster Cooper This St. Petersburg native and Gibbs High graduate became a world-renowned jazz trombonist, playing most notably with Duke Ellington and Lionel Hampton. He played in the house band at the Apollo Theater in Harlem and formed the Cooper Brothers Band. He still plays regularly at the Garden Restaurant on downtown Central Avenue.

George Cooper Buster Cooper's cousin, George formed St. Petersburg's first big, African American band, the George Cooper Orchestra. He led the Manhattan's house band until 1968. Ray Charles sat in with the group in the late 1940s.

Steve Cooper Another in the musical Cooper family, Steve was an upright bass player who joined Buster in the brothers' band and went on to play with Count Basie.

Alvin Downing A pianist and legendary jazz figure in the St. Petersburg area, Downing taught music at Gibbs High School, where he put together a dance band, and later one at St. Petersburg Junior College. He was the first black member of the St. Petersburg symphony.

Bill Doggett He organized his first band in 1938 and joined Lucky Millinder as pianist and arranger. The Bill Doggett Combo became a hot 1950s group, one of whose signature songs was "Honky Tonk" in 1956.

Duke Ellington Born in 1899, James Edward Ellington was the son of a White House butler. Music authorities consider him to be the most influential composer in jazz history. He was a bandleader for a half-century and began

recording during the 1920s. He also wrote musicals and movie scores and won several Grammys. Ellington played at the Melrose Park Clubhouse and Joyland on 6th Avenue South just off 22nd Street.

Ella Fitzgerald She is considered one of the best, if not the best, female jazz singers of all time. She grew up poor, but got a big show business break when she won a talent show in 1934 at the Apollo Theater. She worked with Dizzy Gillespie, Duke Ellington, the Inkspots, Tiny Bradshaw and Chick Webb, among others. Her first big hit was 1938's "A Tisket, A Tasket."

Al Green He began as a gospel singer and became a popular soul singer in the 1970s. A big hit was "Let's Stay Together." An ordained minister, Green continued to sing rhythm and blues into the 1990s. He sometimes danced for change outside the Manhattan.

Manzy Harris Orchestra Harris was a drummer from Tampa and his regional orchestra played regularly at the Manhattan. Harris helped get many young musicians started, among them Ray Charles in the 1940s.

Erskine Hawkins Nicknamed the twentieth-century Gabriel, the trumpeter played jazz, big band music and, later, rhythm and blues. "Tuxedo Junction" was one of his signature songs.

Fletcher Henderson With degrees in chemistry and math, Henderson couldn't get a job because of racism. He went into music and is credited with organizing the first widely recognized jazz big band during the 1920s.

Earl "Fatha" Hines One of the most highly regarded jazz pianists, Hines led bands from the 1920s to the 1940s. He made a career comeback in the 1960s that lasted until he died in 1983.

Ivory Joe Hunter He started singing and playing the piano in the 1930s, but had his biggest hits in the 1950s with "I Almost Lost My Mind" and "Since I Met You, Baby."

B.B. King Born Riley King in the Mississippi Delta where he worked as a sharecropper, he is usually considered the king of the electric blues guitar. In Memphis during the late 1940s, he was called the Beale Street Blues Boy, which later was shortened to Blues Boy, and finally to B.B.

Dizzy Gillespie Perhaps the greatest jazz trumpeter and a leader of great bands, John Birks Gillespie learned to play the trombone as a child. Bebop icon, songwriter and arranger, Gillespie was known for the bent trumpet he usually played with his cheeks puffed out.

The Inkspots This prototype harmony group, which scored a hit with "If I Didn't Care" in 1939, helped set the stage for the 1950s doo-wop sound.

Mahalia Jackson She is often considered the greatest gospel singer ever, male or female. Her 1948 recording of "Move on Up a Little Higher" became the best-selling gospel record of all time and propelled Jackson to super-stardom.

Illinois Jacquet Considered one of the great jazz tenor saxophonists, he played with Cab Calloway, Count Basie and Lionel Hampton, among others.

Little Willie John The 1960s rhythm-and-blues artist was the first to record "Fever" in 1956, two years before Peggy Lee's version.

Buddy Johnson Johnson was a classical pianist who found commercial success in rhythm and blues. His orchestra during the 1940s was a constant presence on the rhythm-and-blues hit parade and packed venues on its national tours.

Ella Johnson Buddy Johnson's sister, she was the orchestra's vocalist during the 1940s and '50s, specializing in ballads and blues.

Eddie Jones (known as Guitar Slim) Influential blues musician whose big hit was 1954's "The Things I Used To Do," backed by Ray Charles on piano.

Louis Jordan A rhythm-and-blues pioneer, the saxophonist led the Tympany Five starting in 1939. In a decade's time, Jordan had more than fifty R&B chart hits, including the humorous first one, "I'm Gonna Leave You on the Outskirts of Town."

Jimmie Lunceford The Jimmie Lunceford Orchestra, a swing band, toured during the 1940s and was noted for its energetic shows.

Frankie Lymon At thirteen years old, he was lead singer with The Teenagers, a doo-wop group whose big hit was "Why Do Fools Fall in Love," recorded in the mid-1950s.

Amos Milburn A pianist specializing in the eight-to-the-bar bass beat style known as boogie-woogie, Milburn had nineteen hits in the 1940s and '50s, including the "Chicken Shack Boogie."

Lucky Millinder Born in Alabama, he grew up in Chicago, worked as a dancer and sang, and in the 1930s, he started leading jazz bands.

The Mills Brothers A harmony group, the Mills family first organized in the 1930s stayed around for decades. Their first big hits were "Tiger Rag" and "Dinah" in the early '30s; their last smash was "Glow Worm" in the early '50s.

Clyde McPhatter and the Drifters Starting as a gospel singer, McPhatter became a major figure in rhythm and blues and soul. He organized the Drifters and had a big hit in 1954, "Money Honey."

Little Junior Parker He was a harmonica player and blues belter who learned from the likes of Sonny Boy Williamson and Howlin' Wolf.

Arthur Prysock He won much of his fame singing with the Buddy Johnson Orchestra during the 1940s and early '50s. He did rhythm and blues, later becoming a balladeer.

Lou Rawls He began as a gospel singer, but switched to jazz and eventually became a highly regarded, silky crooner of the soul genre.

Otis Redding He started his career as a shouter in the Little Richard style, but became more of a balladeer and influential soul singer in the 1960s. His "Sittin' on the Dock of the Bay" became a No. 1 hit after Redding died in a plane crash in 1967, age twenty-six.

Little Richard Shouting, trilling and yelling "Wooo!" Richard Wayne Penniman had hits such as "Good Golly Miss Molly," "Jenny Jenny," "Tutti Frutti" and "Long Tall Sally."

The Five Royales A vocal group that combined doo-wop and blues, the Royales toured and recorded in the 1950s.

Noble Sissle He is considered a major composer and bandleader who emerged about 1915. He helped write shows such as *Shuffle Along* and during the 1920s, recorded more than two-dozen vocals. Longtime 22nd Street resident Paul Barco

recalled Sissle playing a dance hall on the street, but not the Manhattan. Sissle died in Tampa in 1975.

Sister Rosetta Tharpe An energetic gospel singer, she began playing guitar at age six. Later she sang in clubs, helping bring spiritual music into the pop mainstream.

Ike and Tina Turner Theirs was a scorching rhythm-and-blues and rock act that produced twenty-five hits for the R&B charts between 1960 and 1975. Their most famous record is often considered to be "Rocket 88," which for a time was the name of a 22nd Street tavern.

Sarah Vaughan Another top-tier jazz singer, Vaughan got her start with Earl "Fatha" Hines after winning a talent show at New York's Apollo Theater in the early 1940s. She later joined Billy Eckstine's orchestra and worked with bop greats Dizzy Gillespie and Charlie Parker.

Clara Ward She led the flamboyant Ward Singers, a gospel group whose members are said to have worn huge wigs that on one occasion literally touched the ceiling of a venue they played. The group's commercial approach offended some gospel purists.

Albertina Walker and the Caravans Walker formed the Caravans in 1951, and the gospel group became one of the most popular on its circuit. It disbanded in the 1970s, but Walker kept singing, winning a Dove award in 1997 for the best traditional gospel song.

Thomas "Fats" Waller The pianist, known for his humor during shows, introduced to the jazz world the pipe organ, which Waller called "the God box." "Ain't Misbehavin'" and "Honeysuckle Rose" are two of his famous hits.

Chick Webb A drummer and leader during the big band era, Webb was a small man who fought handicaps such as tuberculosis and a humped back. In a "battle of the bands" in Harlem's Savoy Ballroom, Webb's orchestra is said to have trumped Benny Goodman's.

Joe Williams Most widely known for his tenure as vocalist with Count Basie's orchestra, Williams kept singing through most of the 1990s until his death in '99.

Cootie Williams He played trumpet with the orchestras of Chick Webb, Fletcher Henderson and Duke Ellington before leading his own.

Sources for Appendix 4

All Music Guide to Jazz, www.allmusic.com
Biographical Dictionary of American Music, Charles Eugene Claghorn, 1973
Personal interviews with residents
Craig Pittman at the *St. Petersburg Times*
The Playboy Guide to Jazz, Neil Tesser, 1998
St. Petersburg Times files
Soul Music, Michael Haralambos, 1985

Notes from the Authors

Jon Wilson Much of my enthusiasm for this book started with a newspaper project for the *St. Petersburg Times.* Published in July 2002, it was called "The Deuces." It attempted to explore some of the history of St. Petersburg's segregation-era, African American main street. What sparked the project was the city government's effort to begin developing an industrial park on land that once was home to families who lived, worked and played along 22nd Street.

Photographer Jamie Francis and I interviewed people who were moving away from their longtime neighborhood. We heard the rich, oral tradition among people who knew 22nd Street in its heyday. We decided to look deeper into the history of the street, and we started learning about the people who lived there.

After the newspaper project was published, one of the sources for it, Rosalie Peck, wondered whether the two of us might produce a book. She had grown up in the 22nd Street neighborhood and had a wealth of personal stories. The idea excited me and I jumped at a chance to work with an exceptional writer who had such a store of knowledge. Three years later, I feel as though I have a friend who has taught me much and helped me grow.

In 1956, when I was eleven years old, my family moved to St. Petersburg from a small town in western Nebraska. We were pursuing the Florida dream, part of a post–World War II migration that took people from the Midwest and the Northeast to Sunbelt states. As we began to look around our new hometown, people sometimes advised us that we should stay away from certain neighborhoods because that was too close to where the "Coloreds" lived.

Sometimes the descriptive term used was less genteel. Eventually we settled in a tract house in a new, northwest St. Petersburg subdivision. It was far from downtown and the city's older neighborhoods. I don't believe we ever took a drive on 22ⁿᵈ Street.

White kids of that era in St. Petersburg had few occasions to interact with African American kids. I was twenty-one and in the army before meeting and getting to know black people of my own age. We lived together, often spent leisure time together and shared the hardships and fleeting pleasures common to service life. There was prejudice. Naive and usually distracted in one way or another, I was not really aware of it. But I heard the younger African American soldiers—those my age—talk about it. Some were bitter. Others seemed to roll with what life threw them.

I'm sure I held my own prejudices, although I would have been quick to say, "Oh, no, not me!" When my family moved south, the adults cautioned me never to use hateful words or speak disparagingly of black people; they told me to pay no attention to white people who did. We claimed to favor civil rights progress, but paid only lip service. I never participated in a demonstration, and I took few if any risks to underscore what I said I believed in. So I remember Jim Crow from the perspective of someone who saw it from a distance, tsk-tsked and never tried seriously to do anything about it. I can only try to imagine what it must have been like to live with strict segregation and the knowledge that many in the majority community considered me a second-class person based on skin color.

My hope, and Rosalie's, is that this work will help people of all races appreciate an important part of St. Petersburg's story and that it will help people better understand their community. Much more can be said about African American history; so we hope also that someone, seasoned or youthful, will be inspired to dig deeper—and tell more of the tale.

Rosalie Peck It has been said that preparation plus opportunity equals success. I believe that to be true. Sometimes true. Sometimes not. It does not necessarily follow that success is assured based on preparation and the emergence of opportunity. A myriad of variables inherent in the flow of life can and do alter outcome. Negative outcomes happen no matter how well preparation and opportunity conspire to make good things happen. No matter how passionate the dream. Fortunately, for the countless times when positive outcomes do occur, it is because a favorable force called fate steps in to help make dreams come true.

Specifically, in terms of research for this project, it was immediately apparent that my approach to investigation would spring from the position of participant

observer. It so happens that having been born black in a white world, and in so many ways lived the life and circumstances depicted herein, I need not go far beyond memory to offer validation and value to what I trust will be a slice of history worth preserving.

As a native of St. Petersburg, born, bred and educated from the first grade at Jordan Elementary to graduation from Gibbs High School at a time when race and suffocating racial issues reigned supreme, affecting almost every aspect of life, and as an aspiring writer as far back as I can remember, I have always known and am grateful that at long last this is a story told. A story burning in my soul since early childhood. A story aching to be told. This then, for me, bias and all, is one of the fortunate times when preparation plus opportunity equal success. My ambition as a writer is one thing. My preparation, by accident of birth, upbringing and adult life in St. Petersburg, is another. These events, coupled with the blessing of opportunity and fate, complete the unlikely equation that has culminated in writing this book with Jon Wilson. It tells a story that many people know, and one that all others need to know. For the chance to tell it, I'd like to thank God, my parents, James and Octavia Peck and Jon.

This, then, is history. Herstory. History. Ourstory.

And for lo, those many long-gone souls who lived it, suffered it, loved it, persevered and made things happen, good and unforgettable things, using an age-old adage teaching generations to come, then, now and forever their secret of survival, which states: "When life gives you a lemon, make lemonade." This then, and perhaps most of all, is Theirstory. It is to be hoped that any bias on my part as a writer and co-author of this historical work is understandable. And if not, at least forgivable.

For me, it is first and foremost a labor of love. A story about a time and a place in countless lives; profound and bittersweet. The bitter made less soul-searing and less long-term damaging to soul and psyche because of love. The sweet, made sweeter for the same reason. In the midst of "the worst of times and the best of times" for black people once upon a time in a place called St. Petersburg, Florida, U.S.A., we were encouraged to "Hold on. Hold your head up high." We were insulated. Protected by a merciful impenetrable shield of strength. Cushioned and supported by a web of life comprising community. Togetherness. Love. Hope. Faith. Pride. Striving. Determination. All blended with an age-old reliable sense of survival. This, then, is the way we were in St. Petersburg, Florida, U.S.A.

A place called home.

Index

Index